A KIND OF RAPTURE

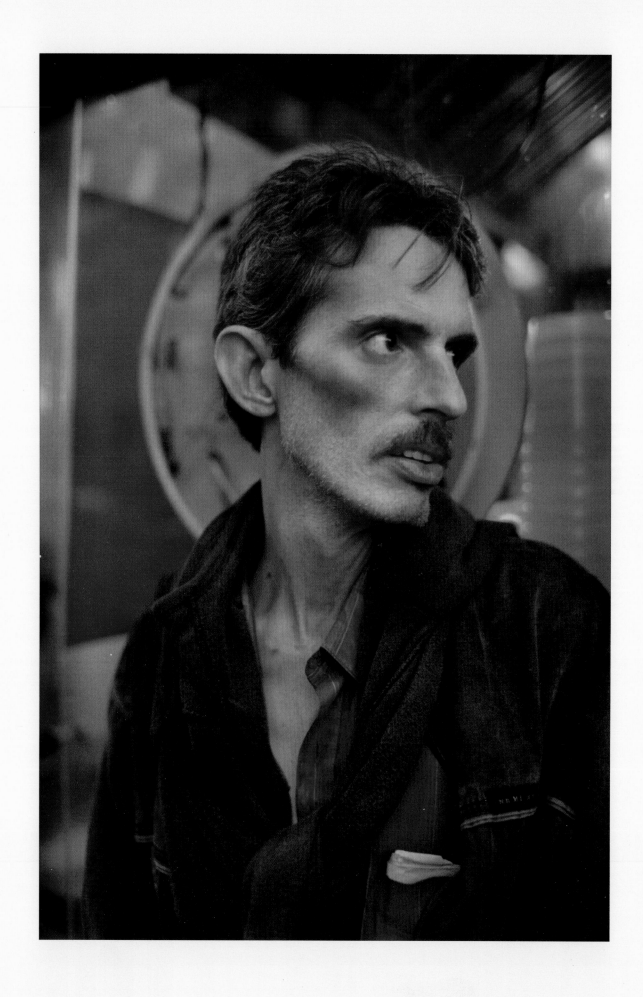

A KIND OF

rapture

ROBERT BERGMAN

INTRODUCTION BY TONI MORRISON

AFTERWORD BY MEYER SCHAPIRO

PANTHEON BOOKS · NEW YORK

Dedicated to the memory of
Daniel Seymour
and
Martin Lenz Harrison

THE FISHERWOMAN

I am in this river place—newly mine—walking in the yard when I see a woman sitting on the seawall at the edge of a neighbor's garden. A homemade fishing pole arcs into the water some twenty feet from her hand. A feeling of welcome washes over me. I walk toward her, right up to the fence that separates my place from the neighbor's, and notice with pleasure the clothes she wears: men's shoes, a man's hat, a well-worn colorless sweater over a long black dress. The woman turns her head and greets me with an easy smile and a "How you doing?" She tells me her name (Mother Something) and we talk for some time—fifteen minutes or so—about fish recipes and weather and children. When I ask her if she lives there she answers, No. She lives in a nearby village, but the owner of the house lets her come to this spot any time she wants to fish, and she comes every week, sometimes several days in a row when the perch or catfish are running and even if they aren't because she likes eel, too, and they were always there. She is witty and full of the wisdom that older women always seem to have a lock on. When we part, it is with an understanding that she will be there the next day or very soon after and we will visit again. I imagine more conversations with her. I will invite her into my house for coffee, for tales, for laughter. She reminds me of someone, something. I imagine a friendship, casual, effortless, delightful.

She is not there the next day. She is not there the following days either. And I look for her every morning. The summer passes and I have not seen her at all. Finally I approach the neighbor to ask about her and am bewildered to learn that the neighbor does not know who or what I am talking about. No old woman fished from her wall—ever— and none had permission to do so. I decide that the fisherwoman had fibbed about the permission and took advantage of the neighbor's frequent absences to poach. The fact of the neighbor's presence is proof that the fisherwoman would not be there. During the months following, I ask lots of people if they know Mother Something. No one, not even people who have lived in nearby villages for seventy years, has ever heard of her. It becomes obvious: she has not moved or died; she has lied to me for some unfathomable reason.

I felt cheated, puzzled, but also amused and wonder off and on if I have dreamed her. In any case, I tell myself, it was an encounter of no value other than anecdotal. Still. Little by little, annoyance then bitterness takes the place of my original

bewilderment. A certain view from my windows is now devoid of her, reminding me every morning of her deceit and my disappointment. What was she doing in that neighborhood anyway? She didn't drive, had to walk four miles if indeed she lived where she said she did. How could she be missed on the road in that hat, those awful shoes? I try to understand the intensity of my chagrin, and why I am missing a woman I spoke to for fifteen minutes. I get nowhere except for the stingy explanation that she had come into my space (next to it anyway—at the property line, at the edge, just at the fence where the most interesting things always happen), and had implied promises of female comradery, of opportunities for me to be generous, of protection and protecting. Now she is gone, taking with her my good opinion of myself, which, of course, is unforgivable. And isn't that the kind of thing that strangers do and that we fear they will do? Disturb. Betray. Prove they are not like us? That is why it is so hard to know what to do with them. The love that prophets have urged us to offer the stranger is the same love which Jean-Paul Sartre could reveal as the very mendacity of Hell. The signal line of *No Exit*, "L'enfer c'est les autres," raises the possibility that "other people" are responsible for turning a personal world into a public hell.

In the admonition of a prophet and the sly warning of an artist, strangers as well as the beloved are understood to tempt our gaze to slide away or to stake claims. Religious prophets caution against the slide, the looking away; Sartre warns against love as possession.

The resources available to us for benign access to each other, for vaulting the mere blue air that separates us, are few but powerful: language, image, and experience, which may involve both, one, or neither of the first two. Language (saying, listening, reading) can encourage, even mandate, surrender, the breach of distances among us, whether they are continental or on the same pillow, whether they are distances of culture or the distinctions and indistinctions of age or gender, whether they are the consequences of social invention or biology. Image increasingly rules the realm of shaping, sometimes becoming, often contaminating, knowledge. Provoking language or eclipsing it, an image can determine not only what we know and feel, but also what we believe is worth knowing about what we feel.

These two godlings, language and image, feed and form experience. My instant embrace of an outrageously dressed fisherwoman was in part because of an image on which my representation of her was based; the image was supported by lan-

guage—swiftly intimate with the curls and curves I recognized. I immediately sentimentalized and appropriated her. Fantasized her as my personal shaman. I owned her or wanted to (and I suspect she glimpsed it). I had forgotten the power of embedded images and stylish language to seduce, reveal, control. Forgot too their capacity to help us to pursue the human project—which is to remain human and to block the dehumanization of others. If we are lazy the godlings can hinder us in that project; if we are alert they can foster it.

But something unforeseen has entered into this admittedly oversimplified menu of our resources. Far from our original expectations of increased intimacy and broader knowledge, routine media presentations deploy images and language that narrow our view of what humans look like (or ought to look like) and what in fact we are like. Successful merchandising, pivoting as it does on standards and generalizations, limits our scope in order to delimit our desire and in so doing abjure those who do not or cannot buy. While succumbing to the perversions of media can blur vision, resisting them can do the same. I was clearly and aggressively resisting such influences in my encounter with the fisherwoman. Art as well as the market can be complicit in the sequestering of form from formula, of nature from artifice, of

humanity from commodity. Art gesturing toward representation has, in some exalted quarters, become literally beneath contempt. The concept of what it is to be human has altered, and the word *truth* so needs quotation marks around it that its absence (its elusiveness) is stronger than its presence.

Why should we want to know a stranger when it is easier to estrange another? Why should we want to close the distance when we can close the gate? Appeals in arts and religion for comity in the Common Wealth are faint.

It took some time for me to understand my unreasonable claims on that fisherwoman. To understand that I was longing for and missing some aspect of myself, and that there are no strangers. There are only versions of ourselves, many of which we have not embraced, most of which we wish to protect ourselves from. For the stranger is not foreign, she is random; not alien but remembered; and it is the randomness of the encounter with our already known—although unacknowledged—selves that summons a ripple of alarm. That makes us reject the figure and the emotions it provokes—especially when these emotions are profound. It is also what makes us want to own, govern, or administrate the Other. To romance her, if we can back into our own mirrors.

In either instance (of alarm or false reverence), we deny her personhood, the specific individuality we insist upon for ourselves.

Occasionally there arises an event or a moment that one knows immediately will forever mark a place in the history of artistic endeavor. Robert Bergman's portraits represent such a moment, such an event. In all its burnished majesty his gallery refuses us unearned solace and one by one by one each photograph unveils *us*, asserting a beauty, a kind of rapture, that is as close as can be to a master template of the singularity, the community, the unextinguishable sacredness of the human race.

Toni Morrison

If there is a theme with which I am particularly concerned, it is the contemporary failure of love. I don't mean romantic love or sexual passion, but the love which is the specific and particular recognition of one human being by another—the response by eye and voice and touch of two solitudes. The democracy of universal vulnerability.

Isabella Gardner

A KIND OF RAPTURE

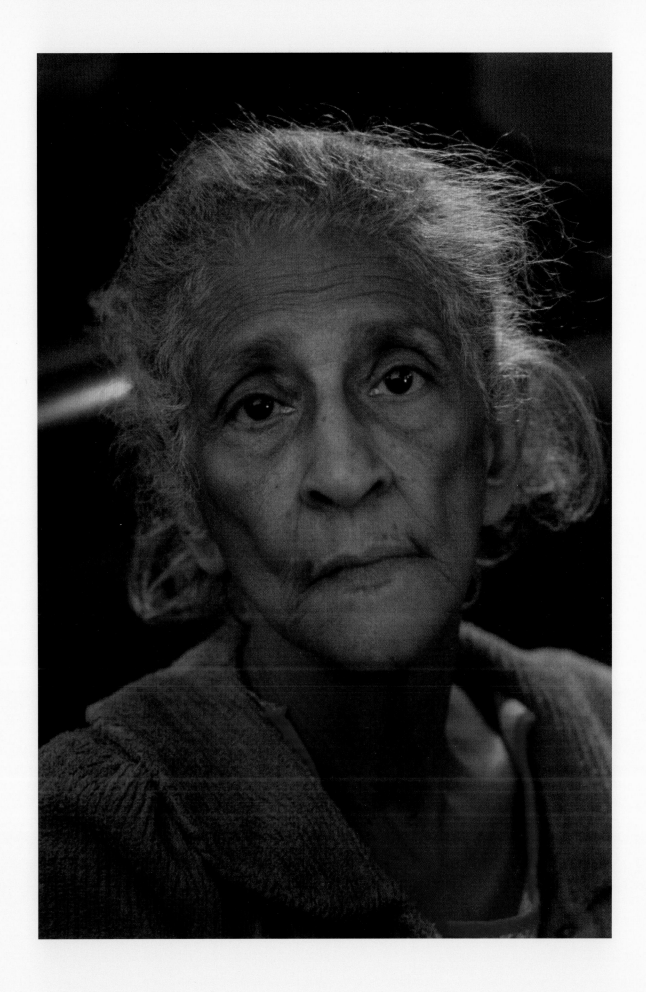

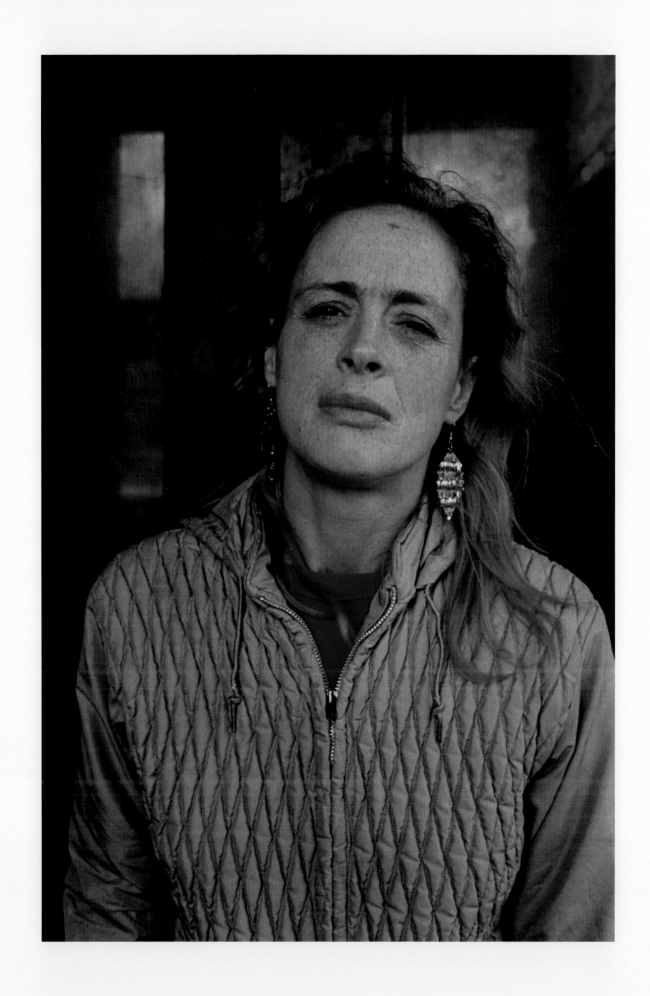

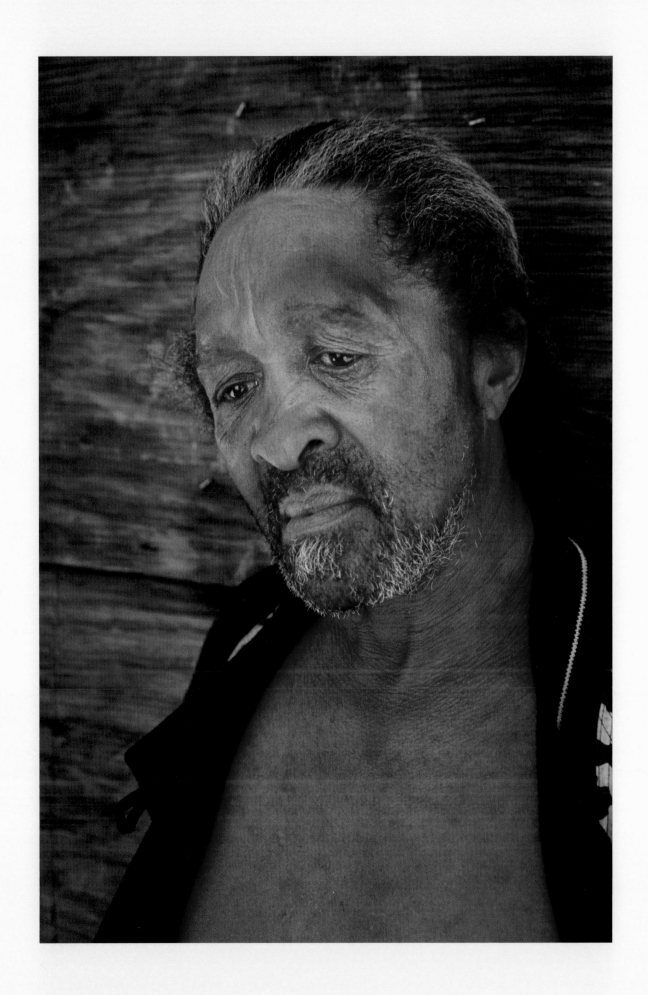

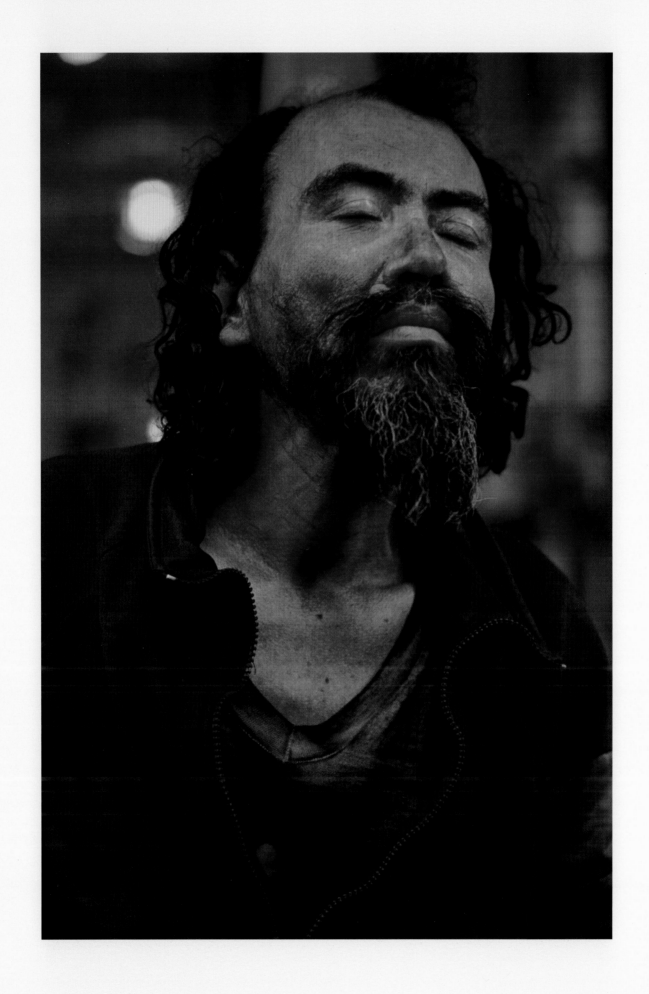

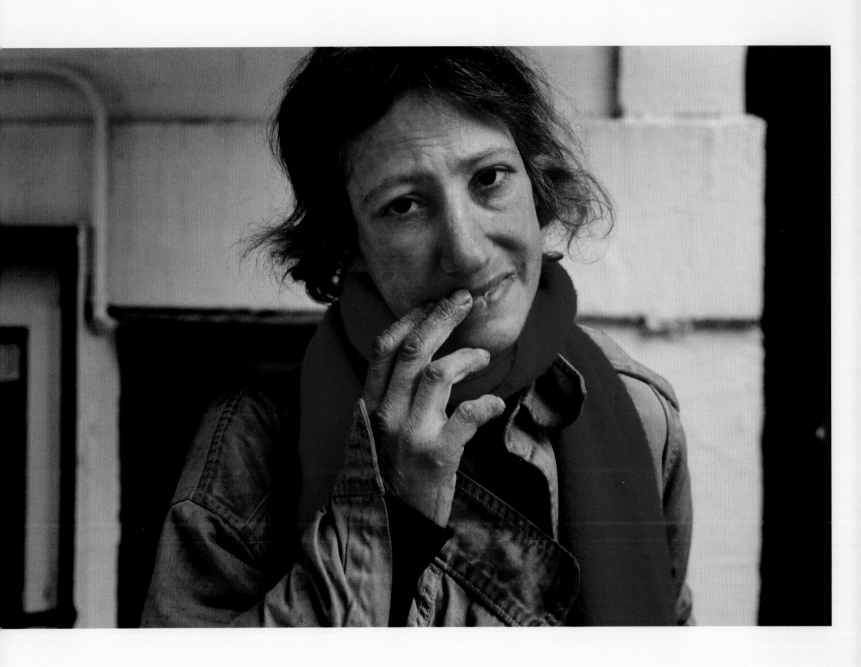

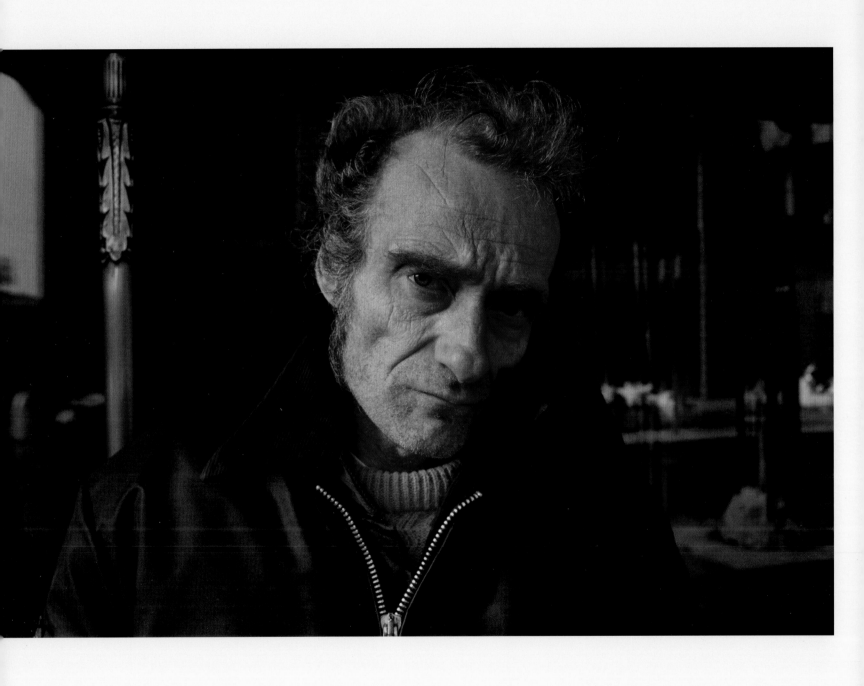

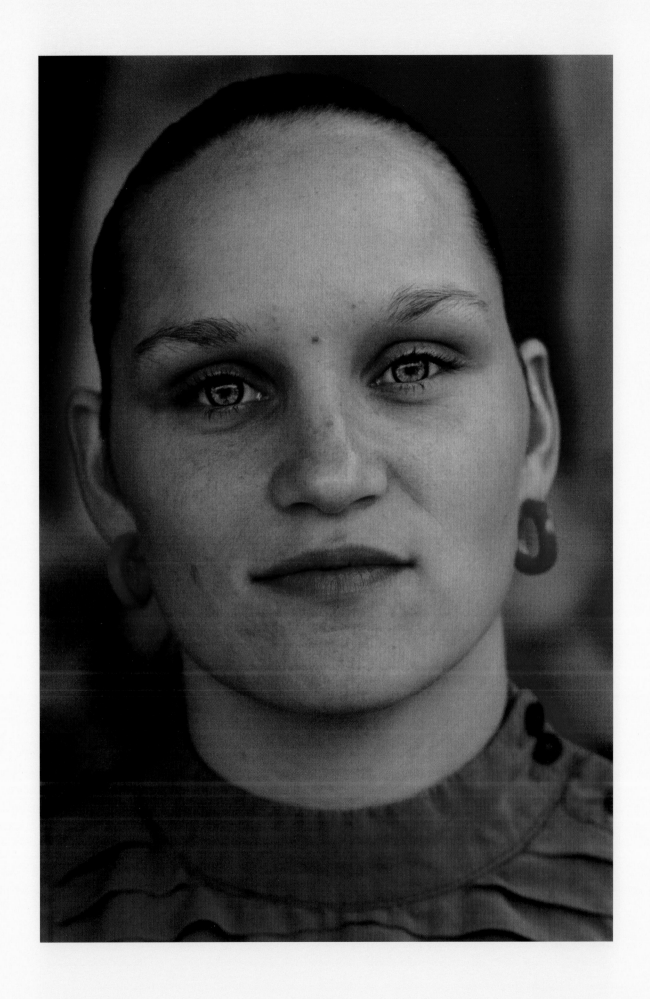

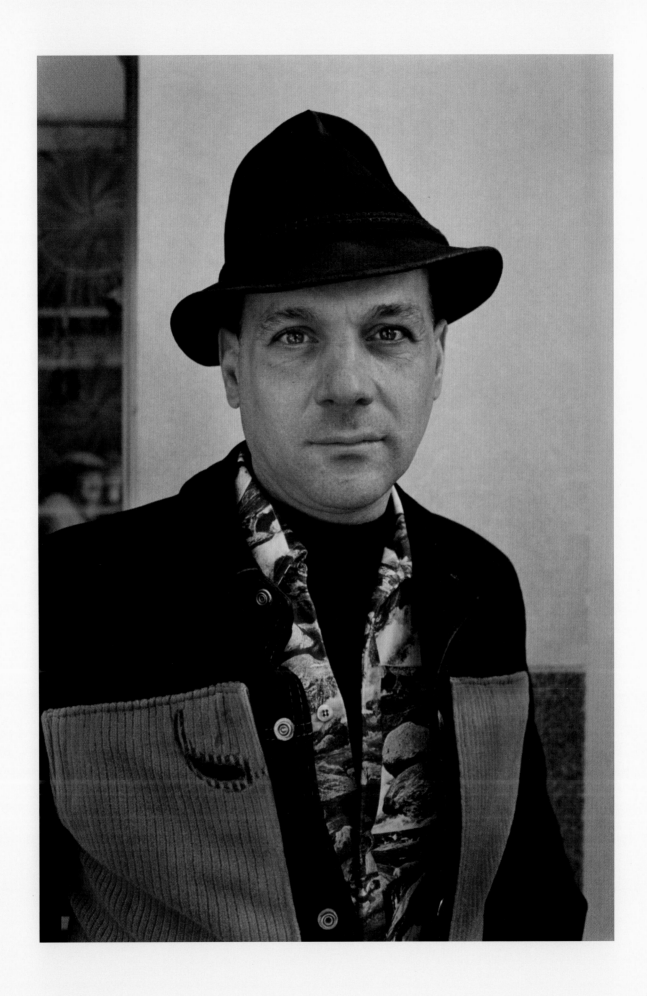

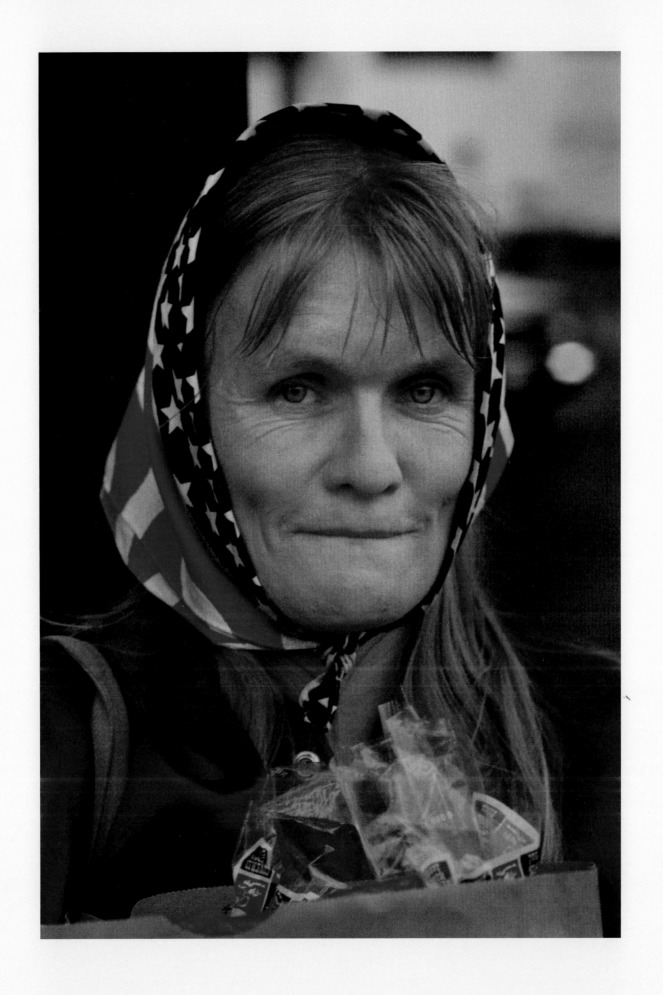

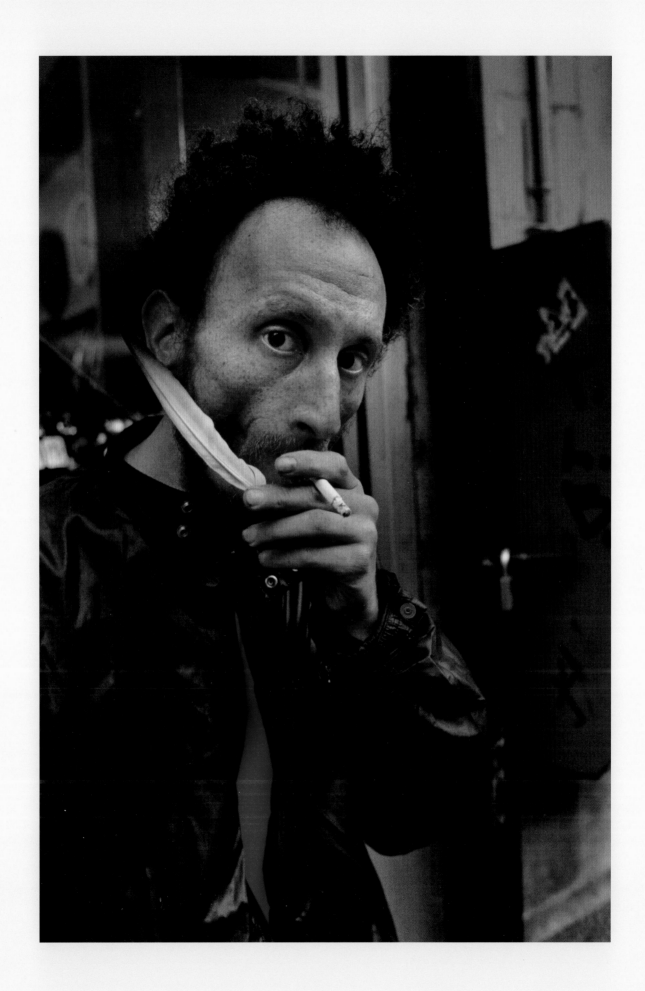

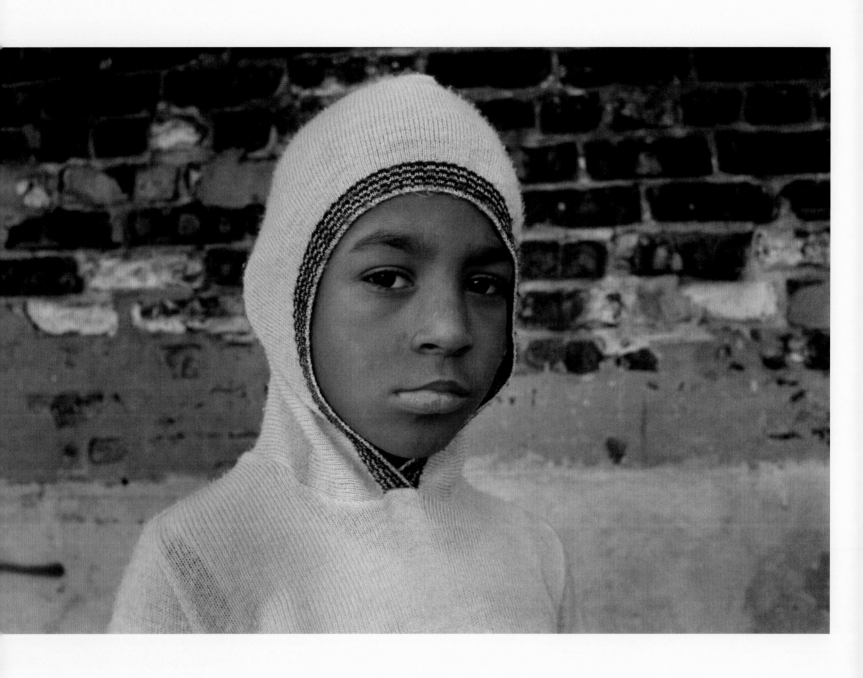

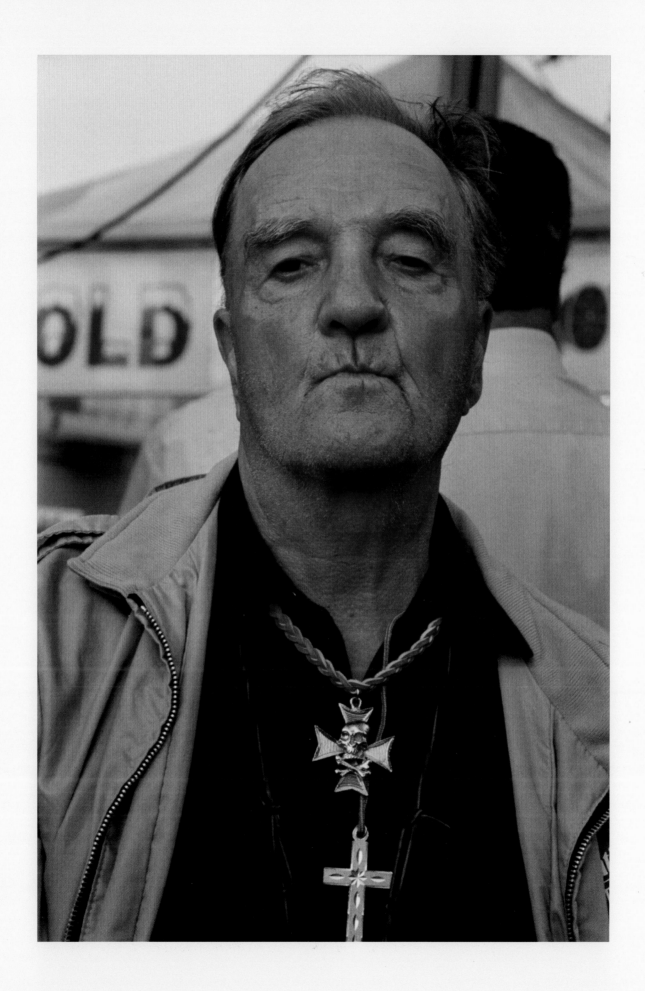

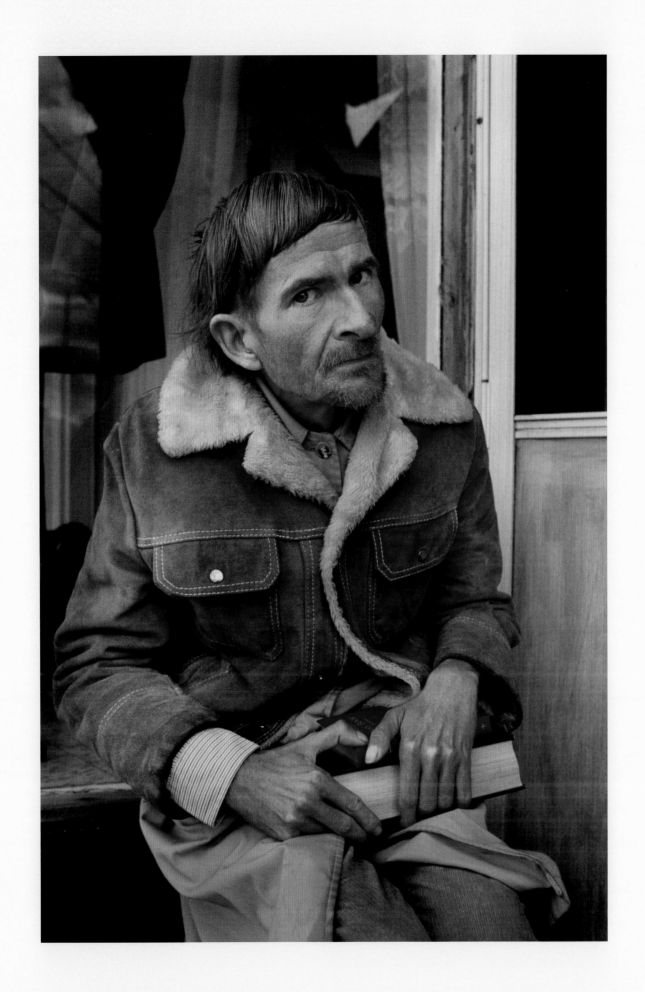

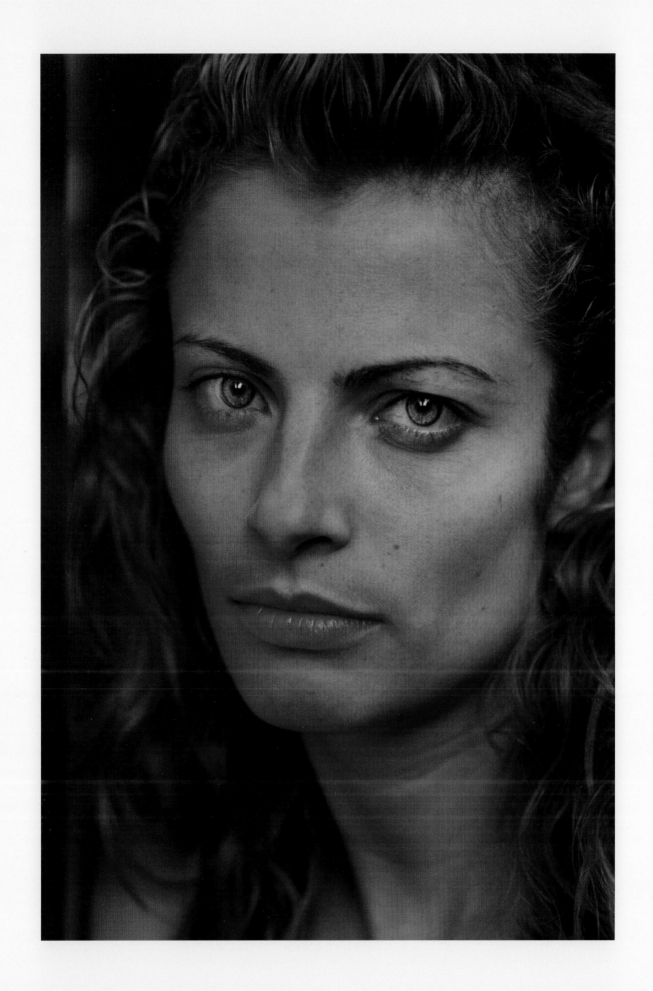

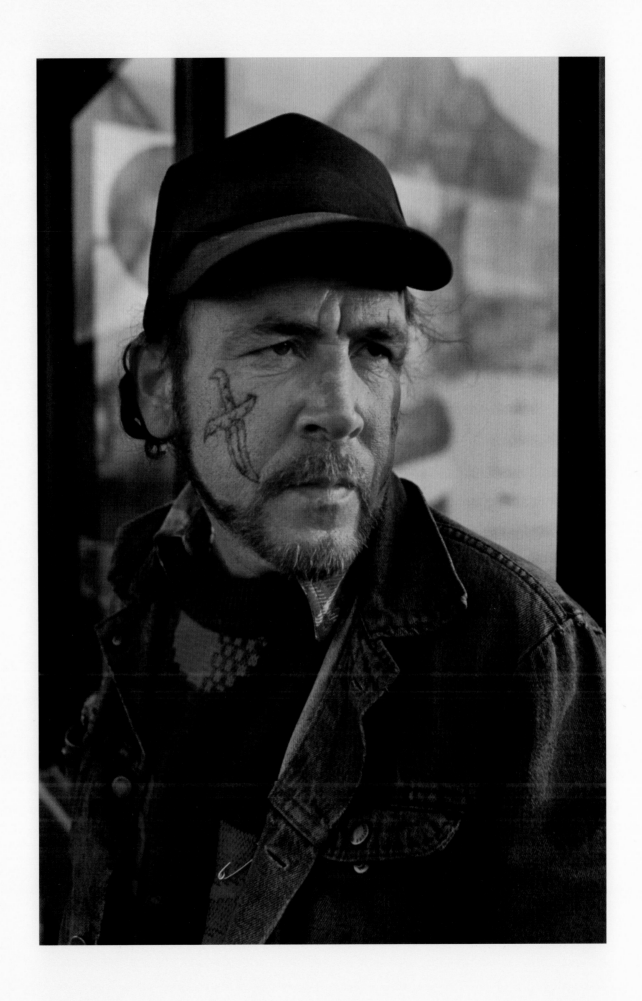

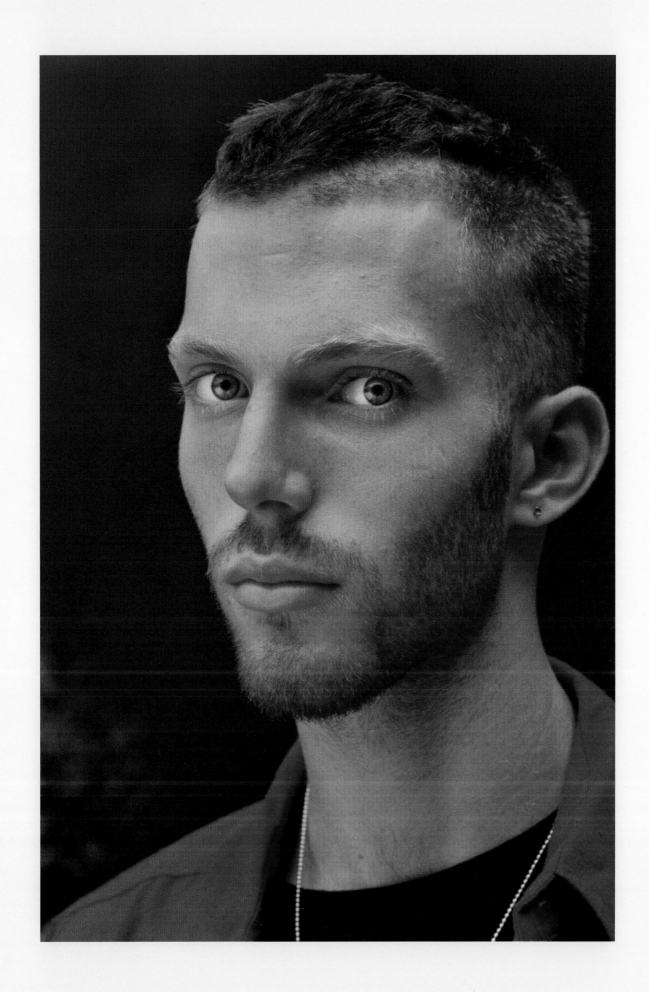

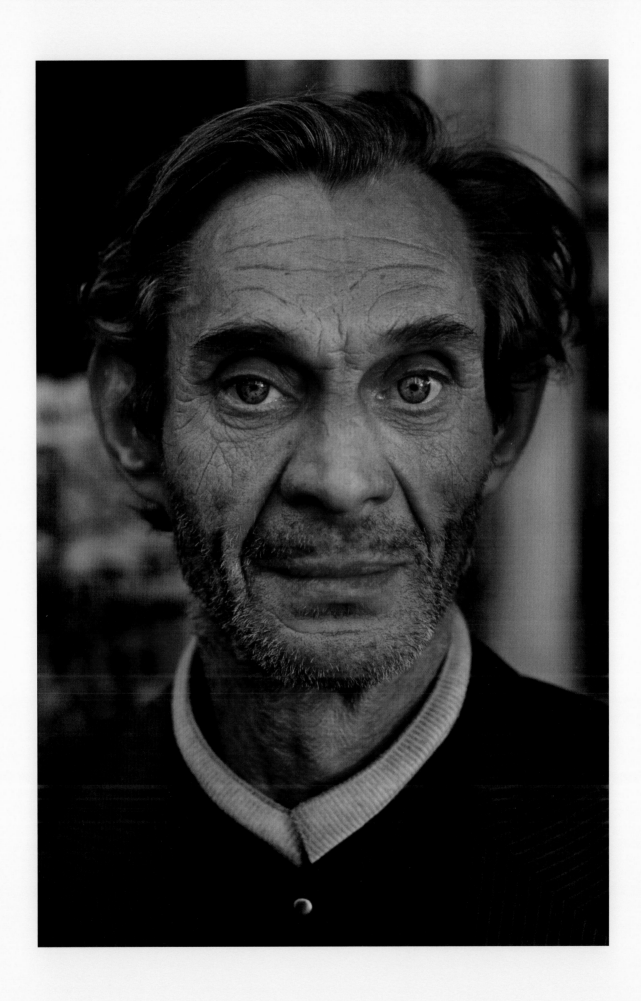

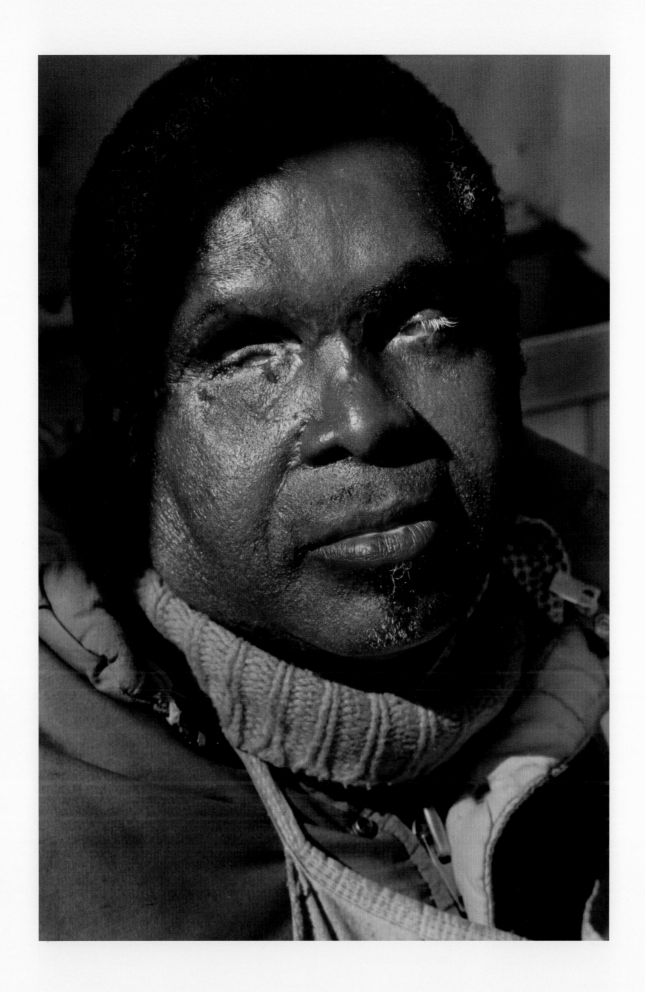

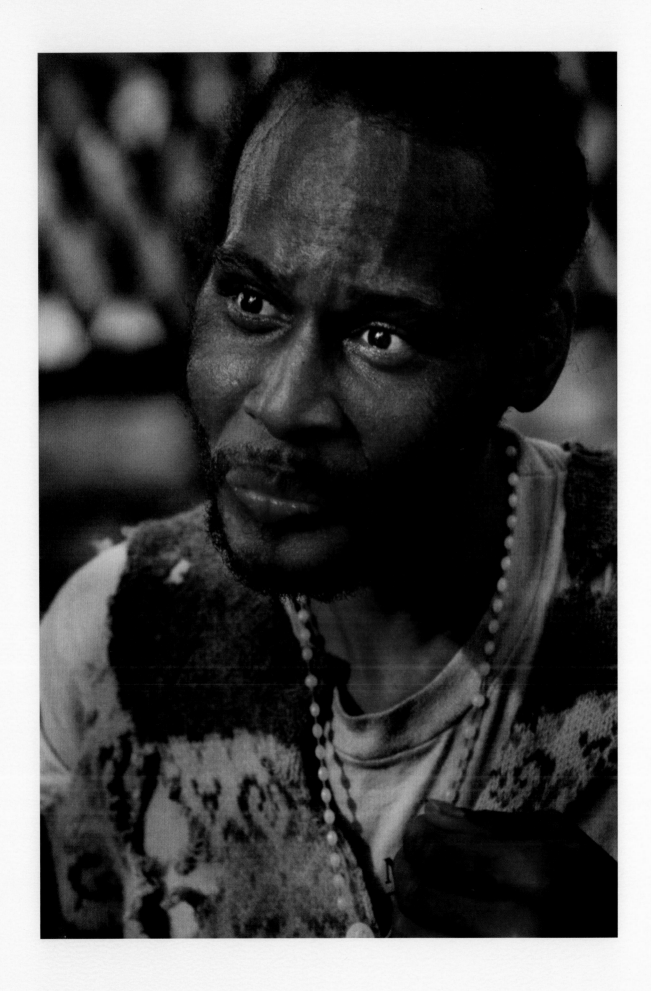

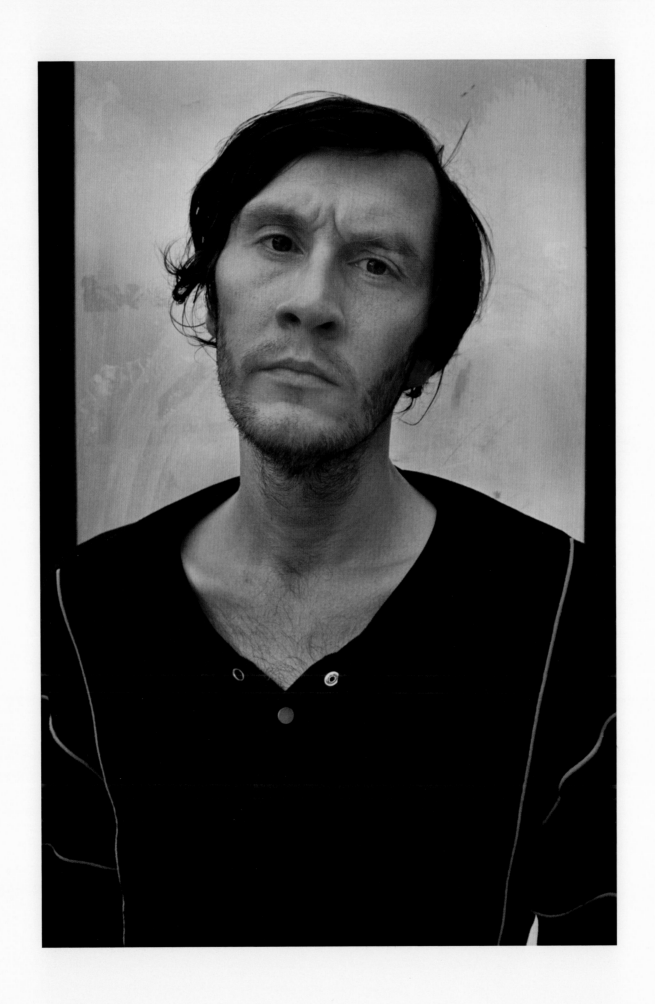

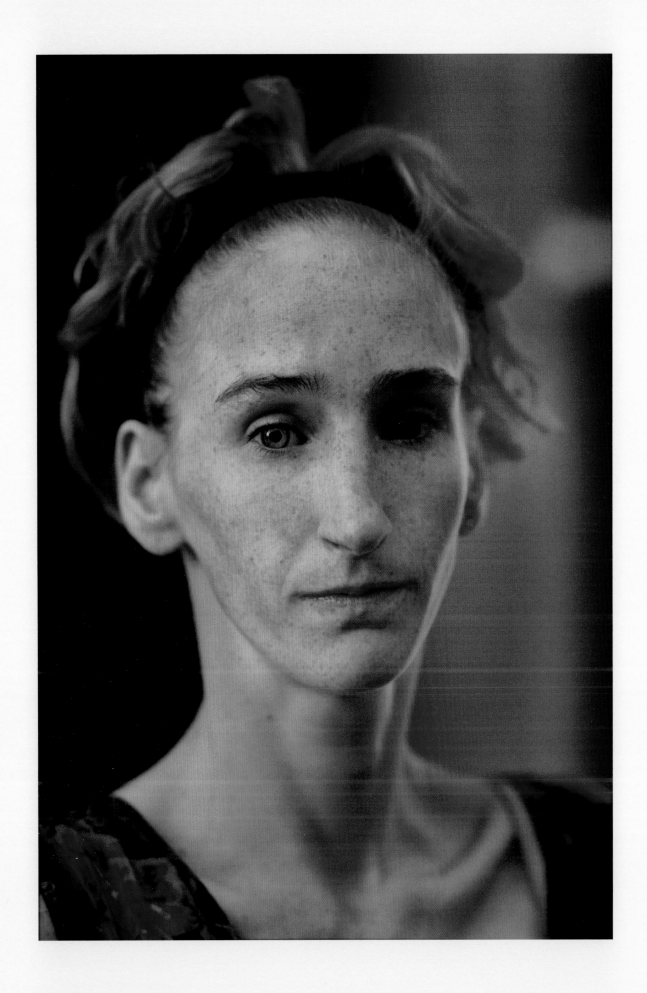

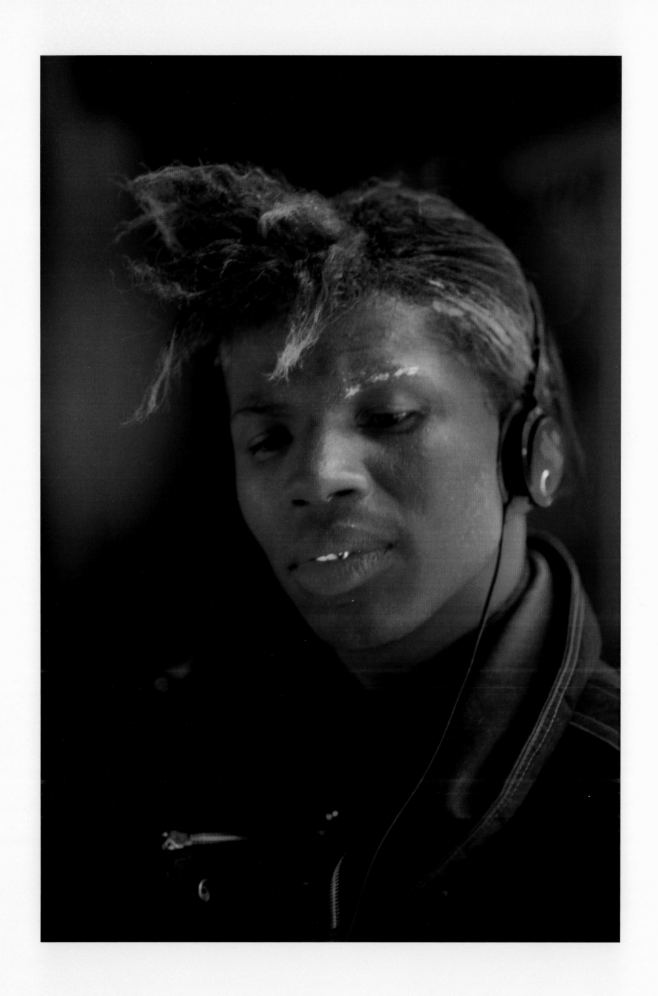

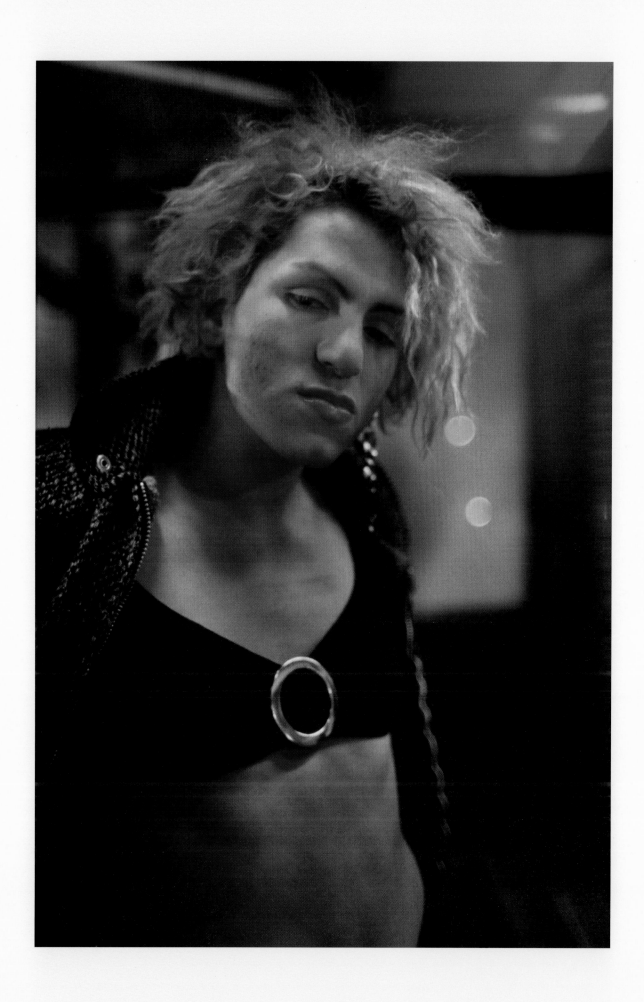

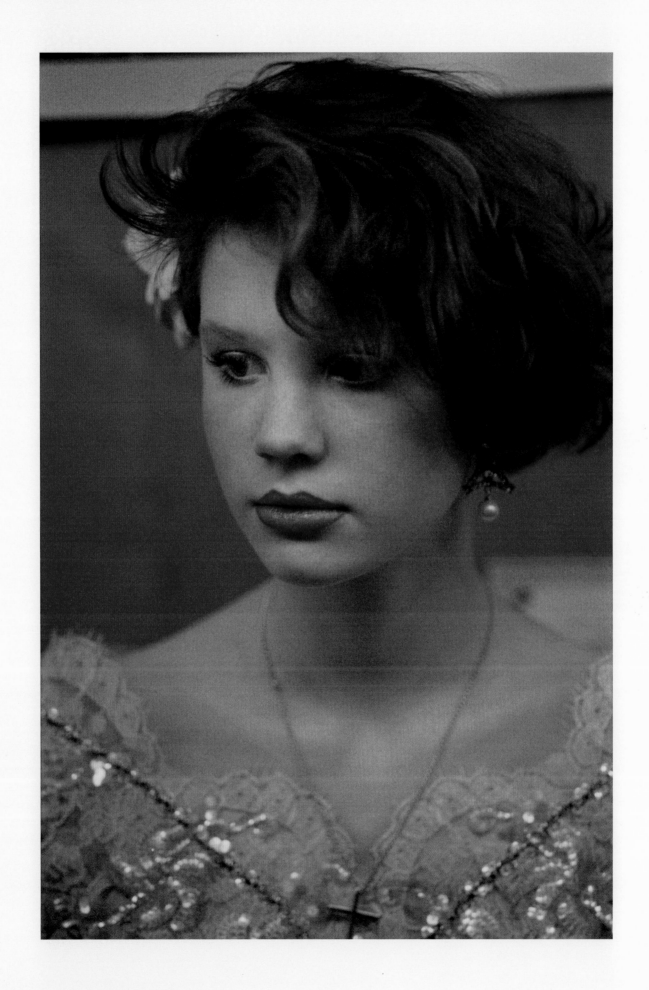

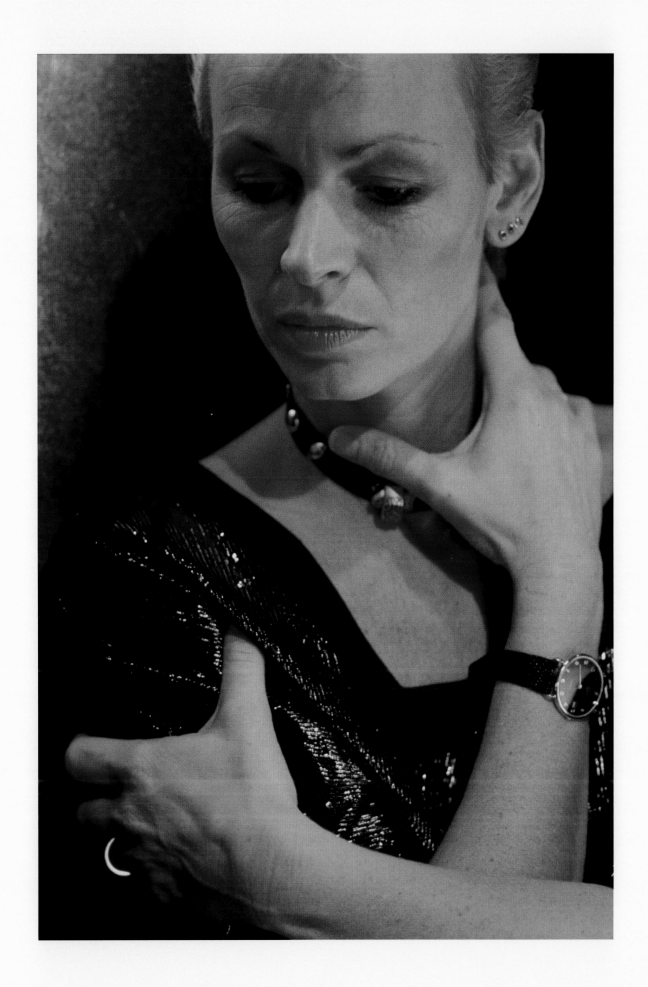

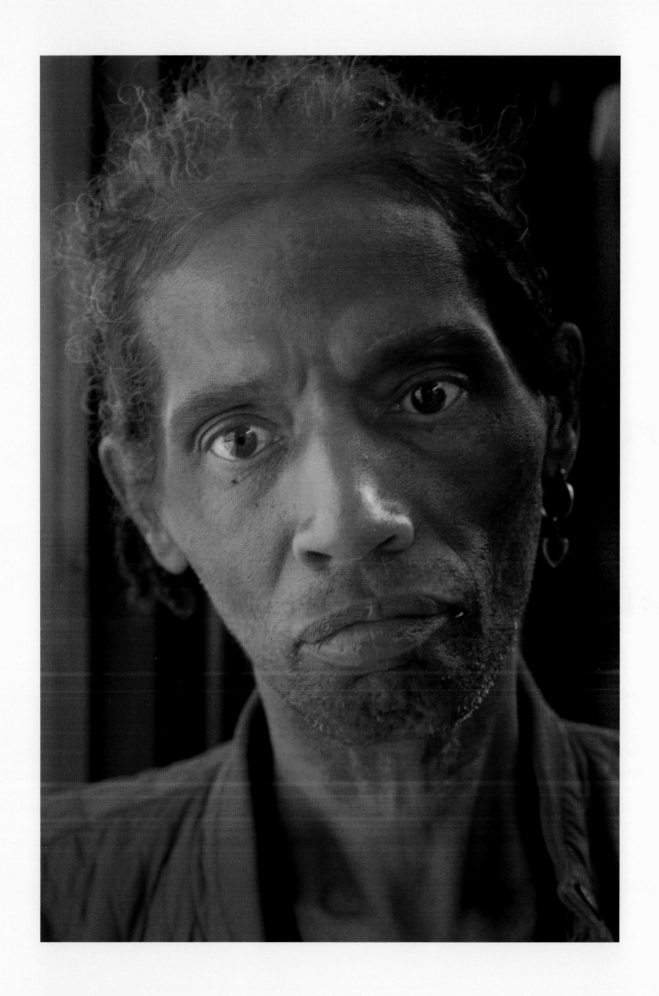

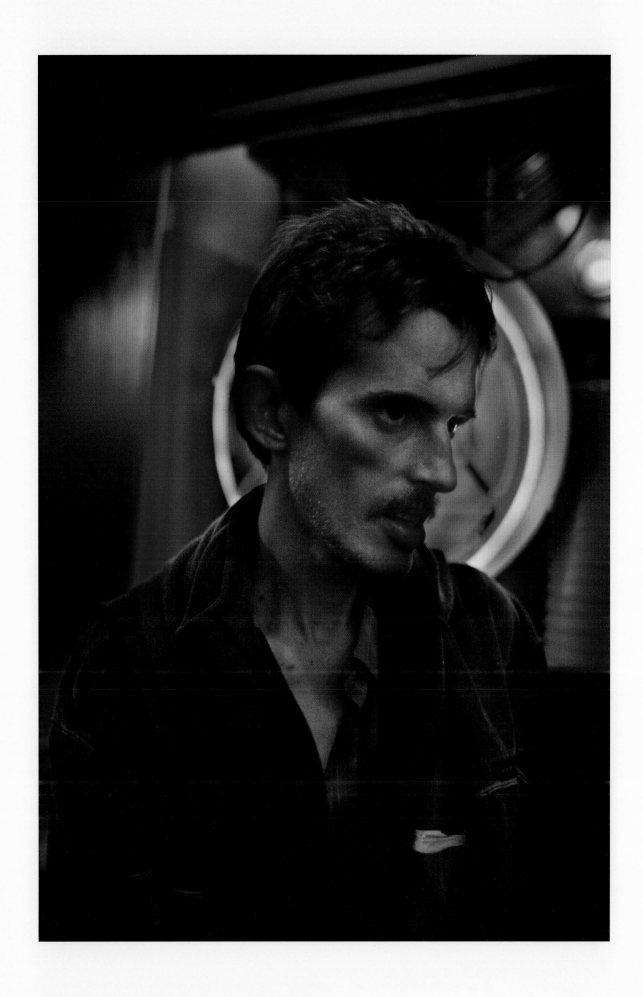

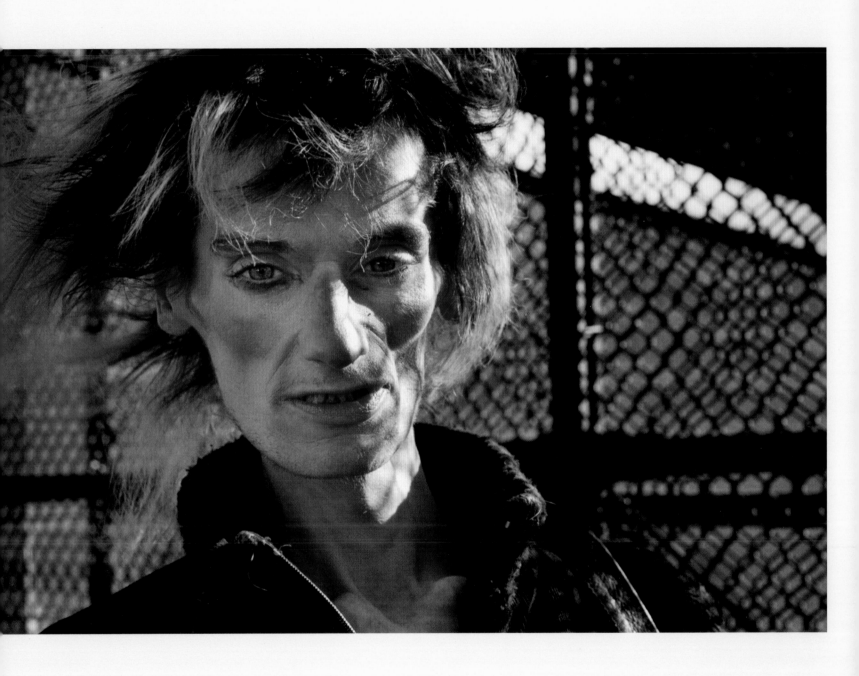

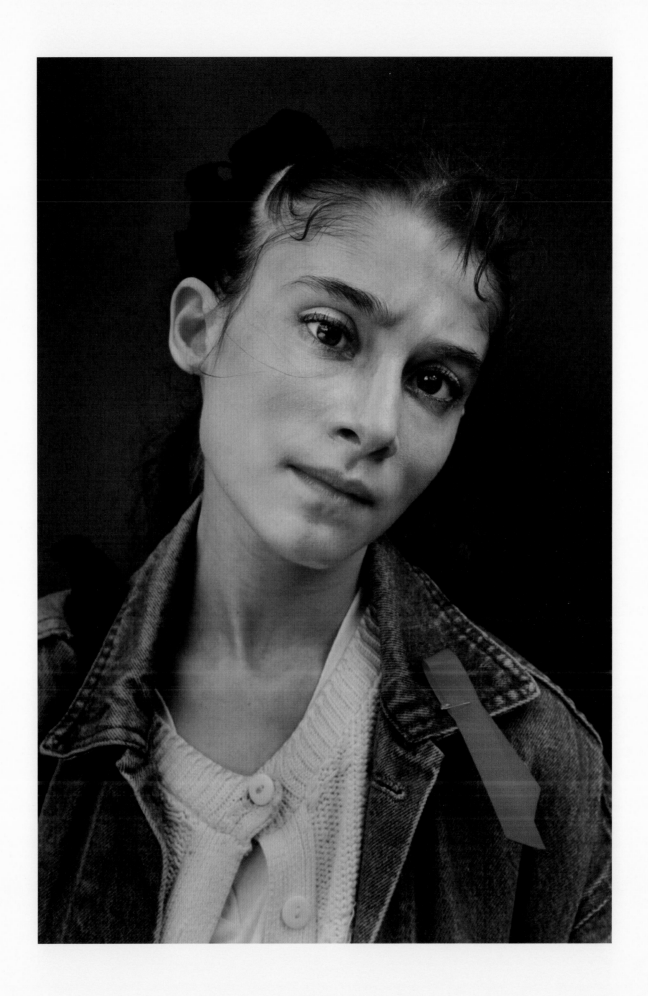

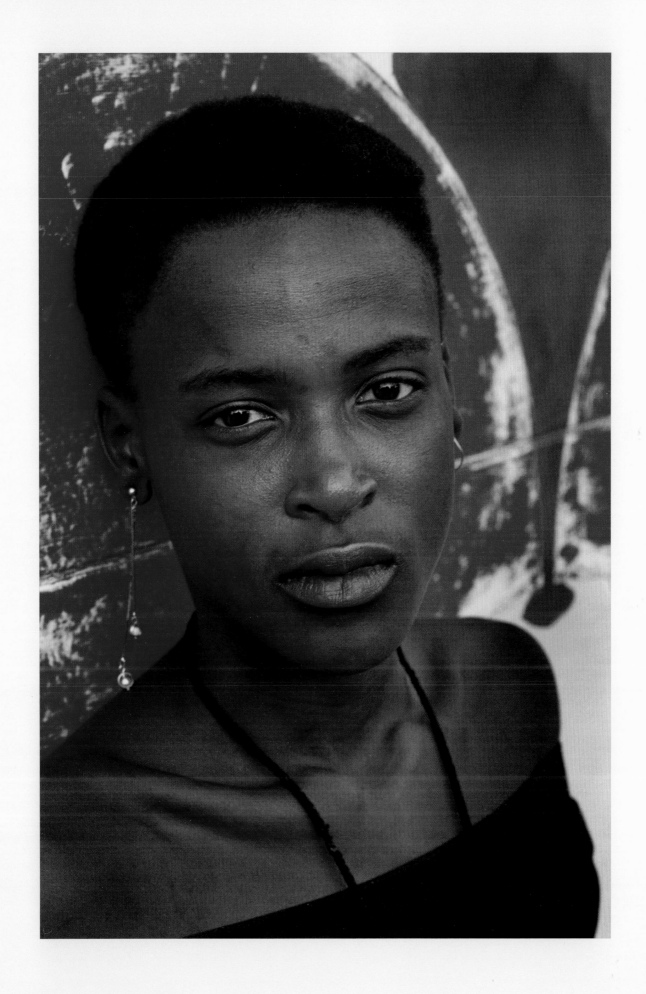

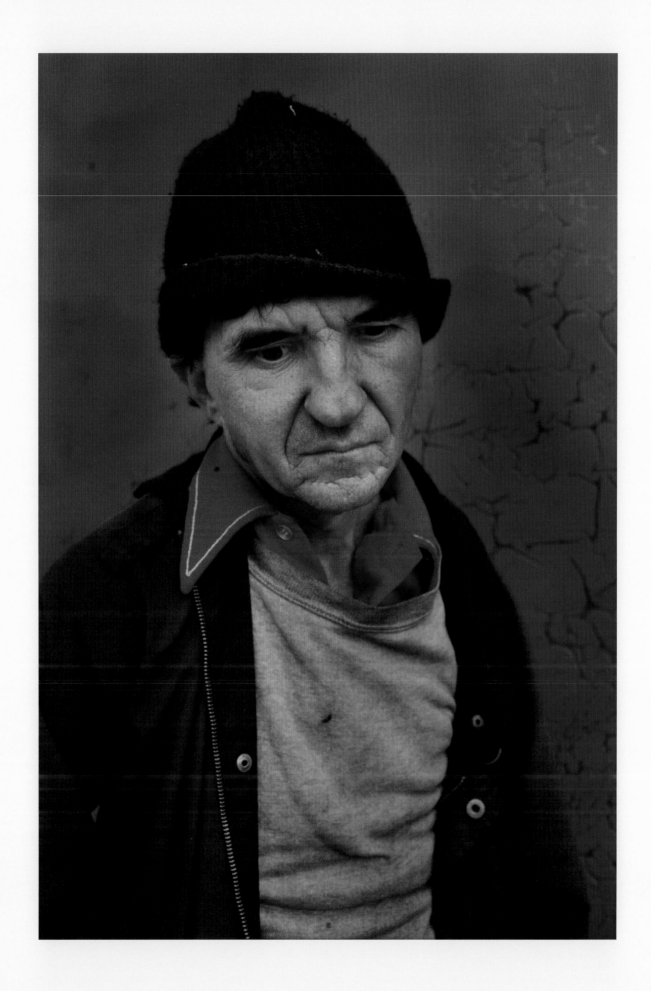

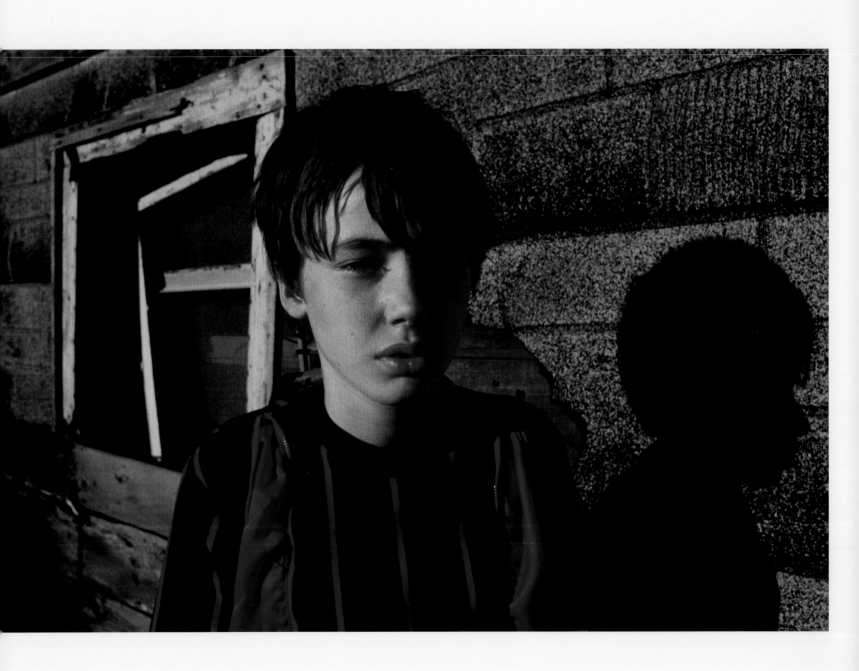

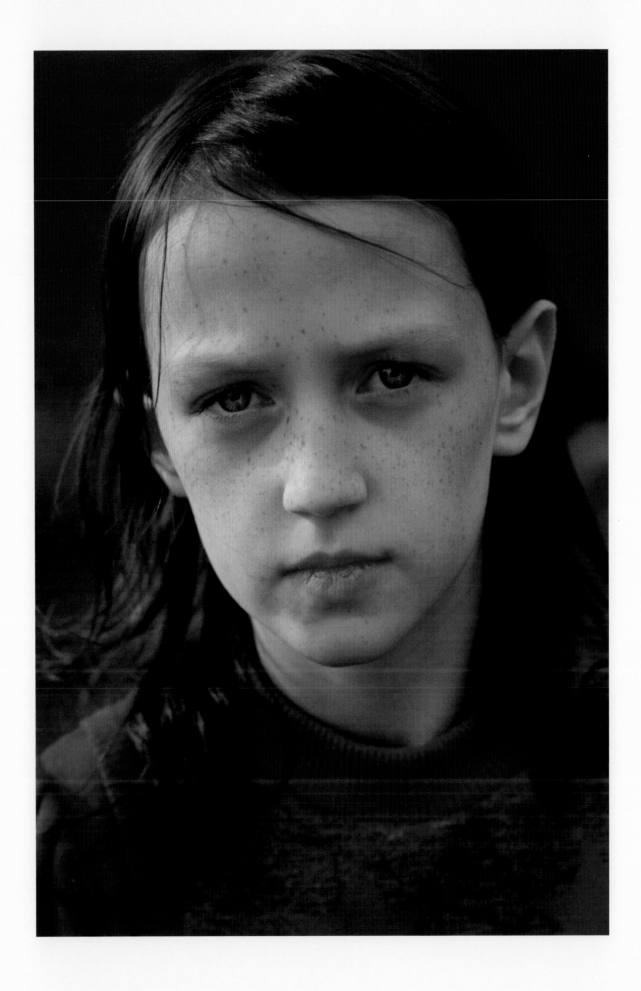

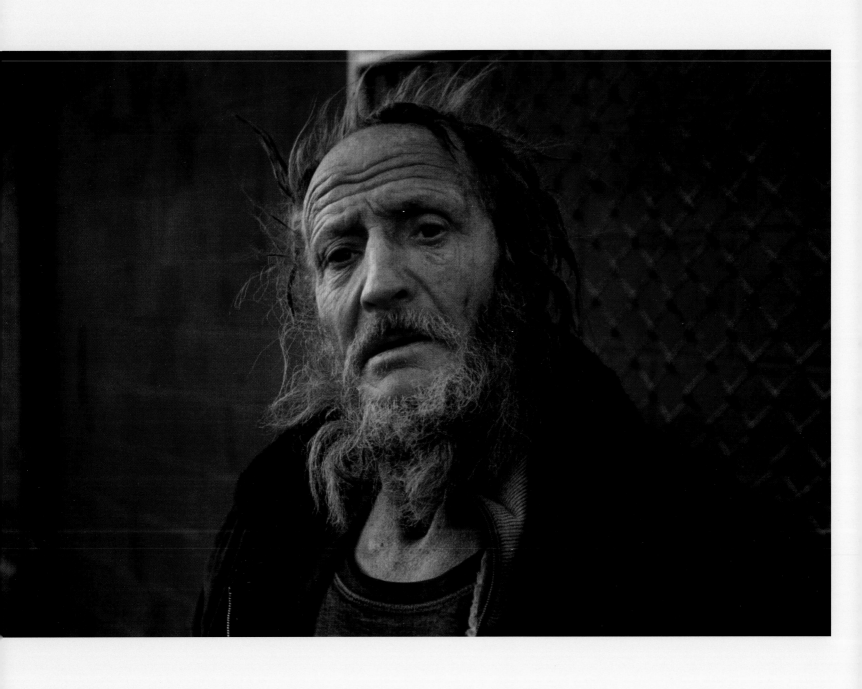

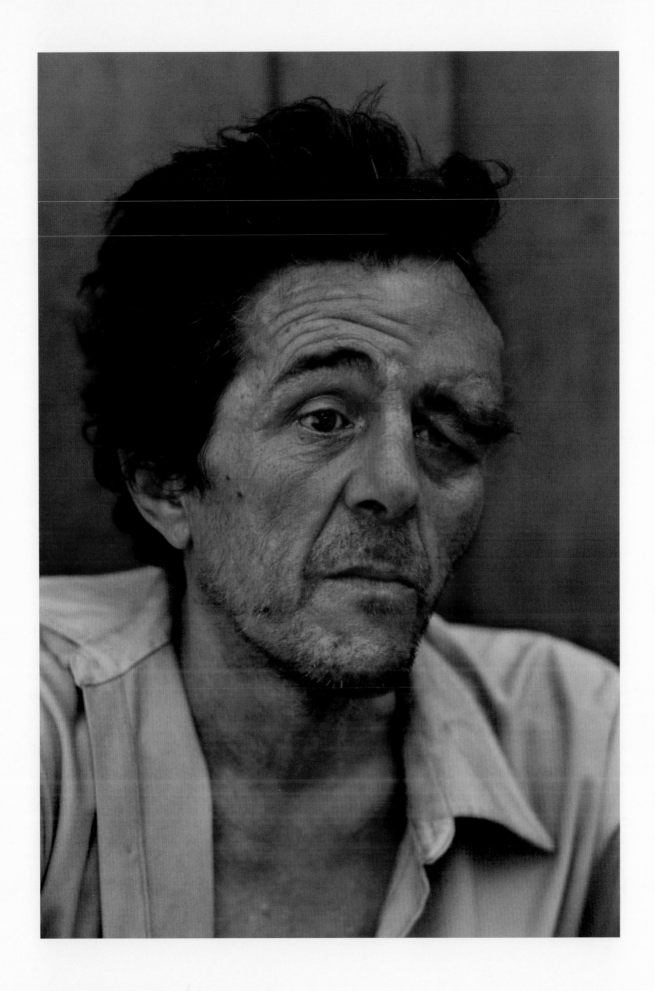

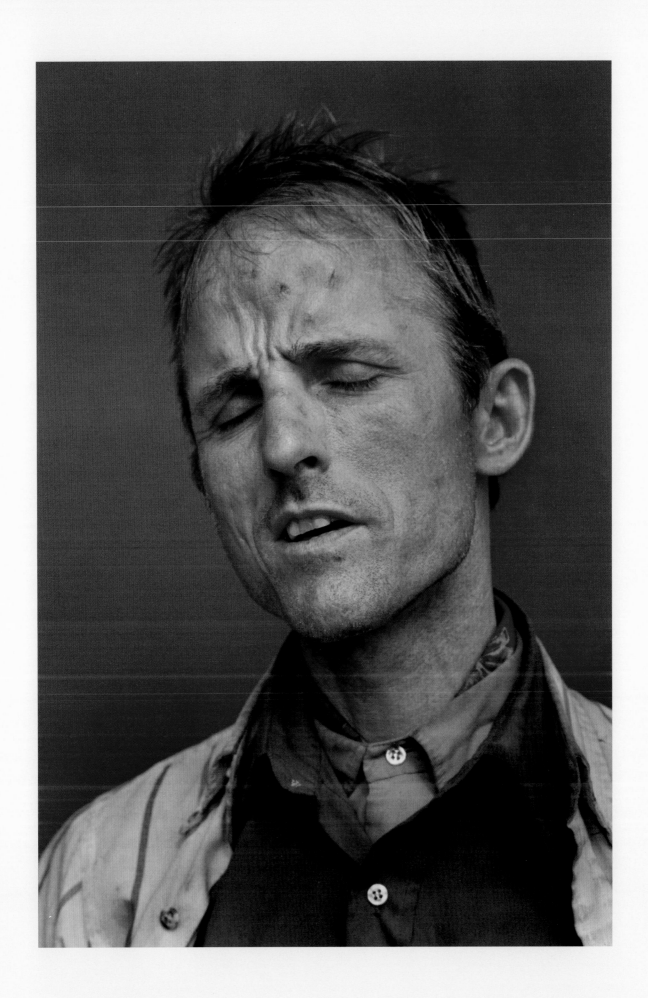

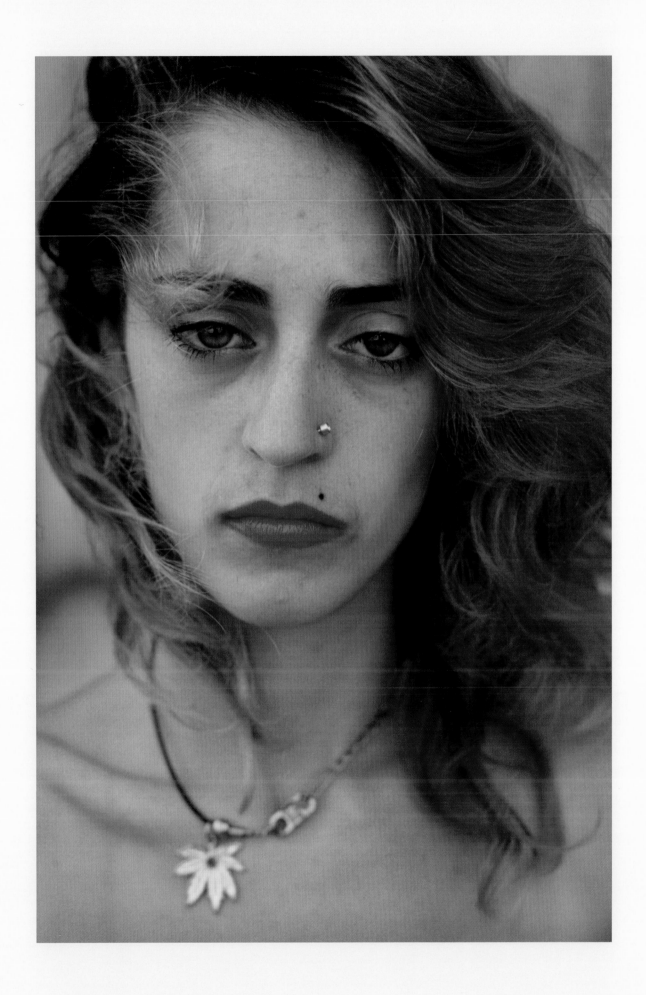

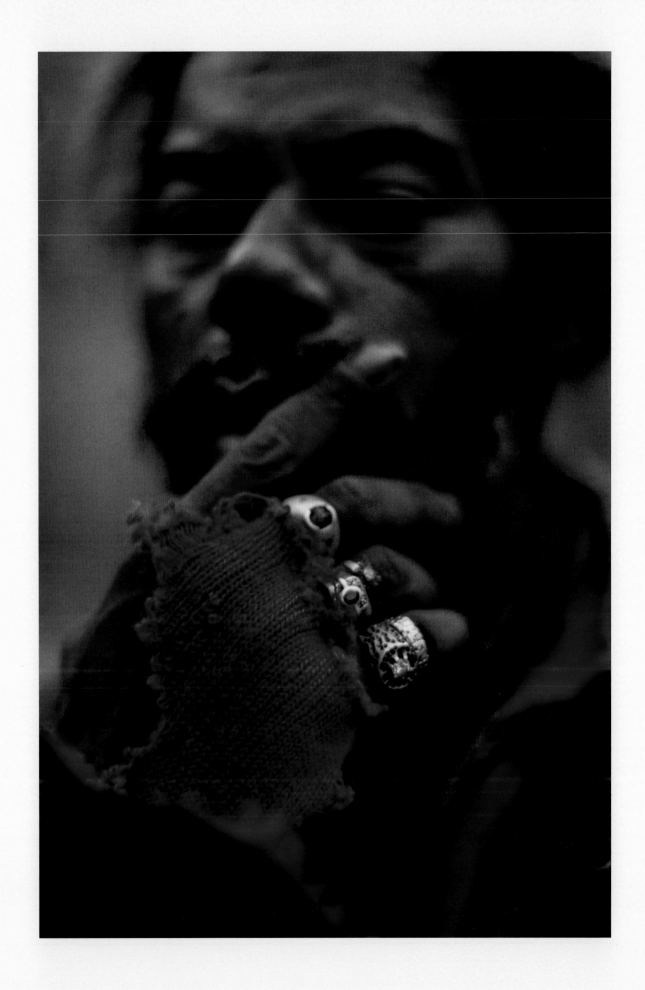

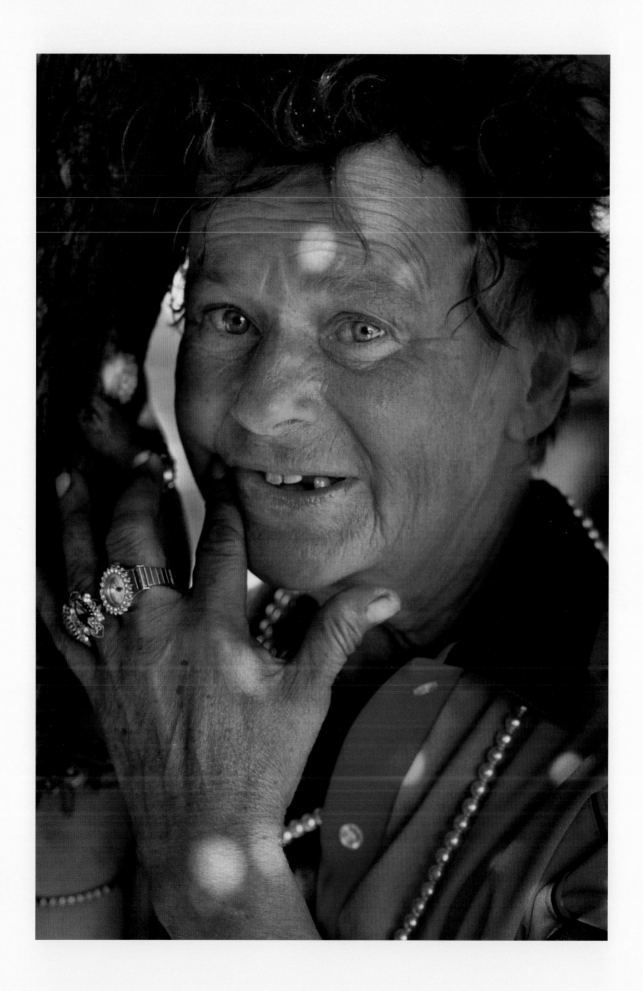

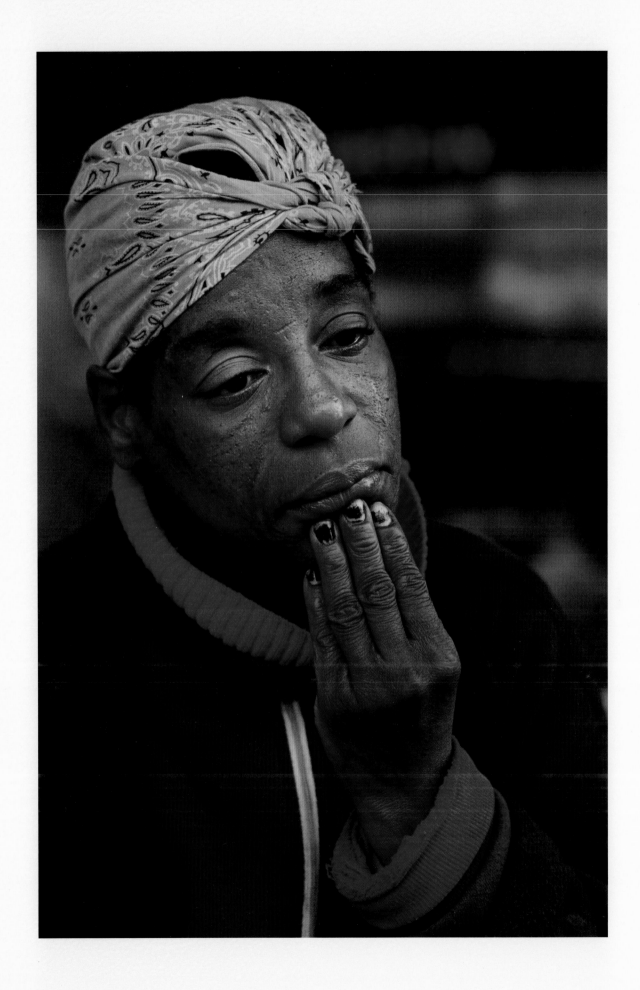

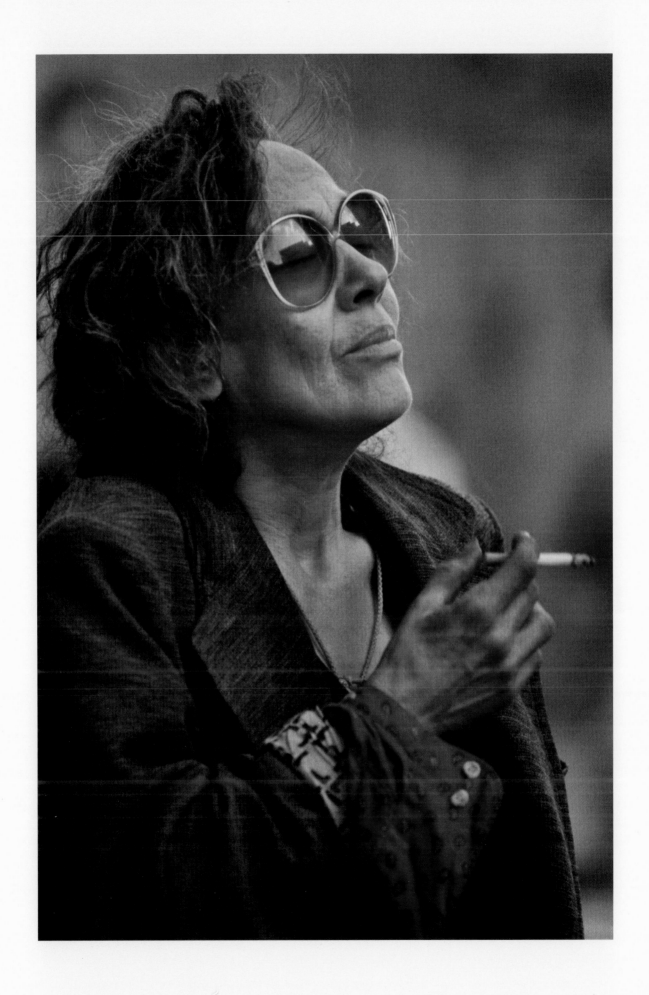

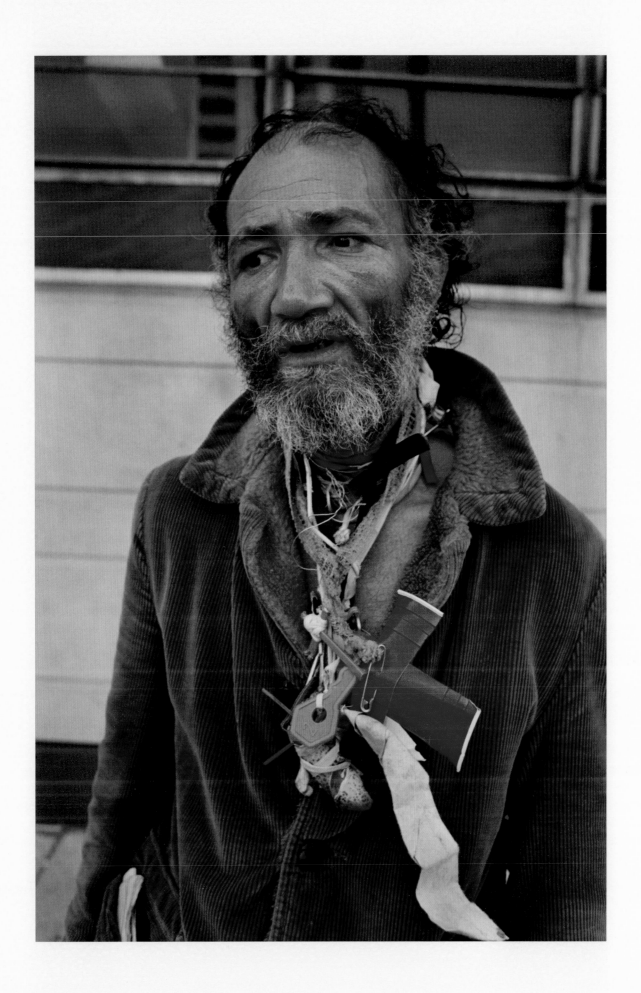

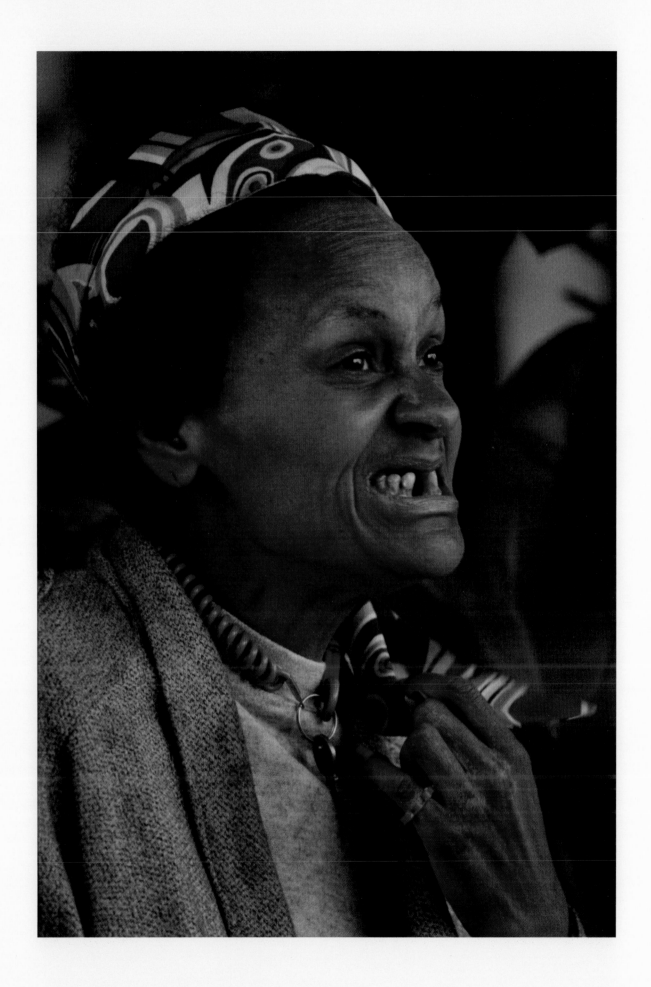

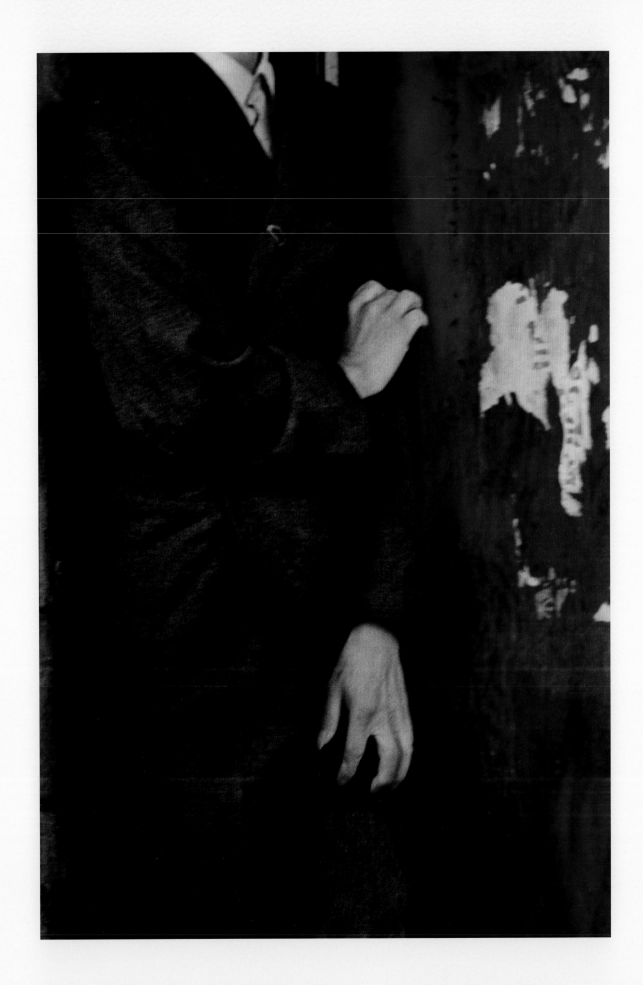

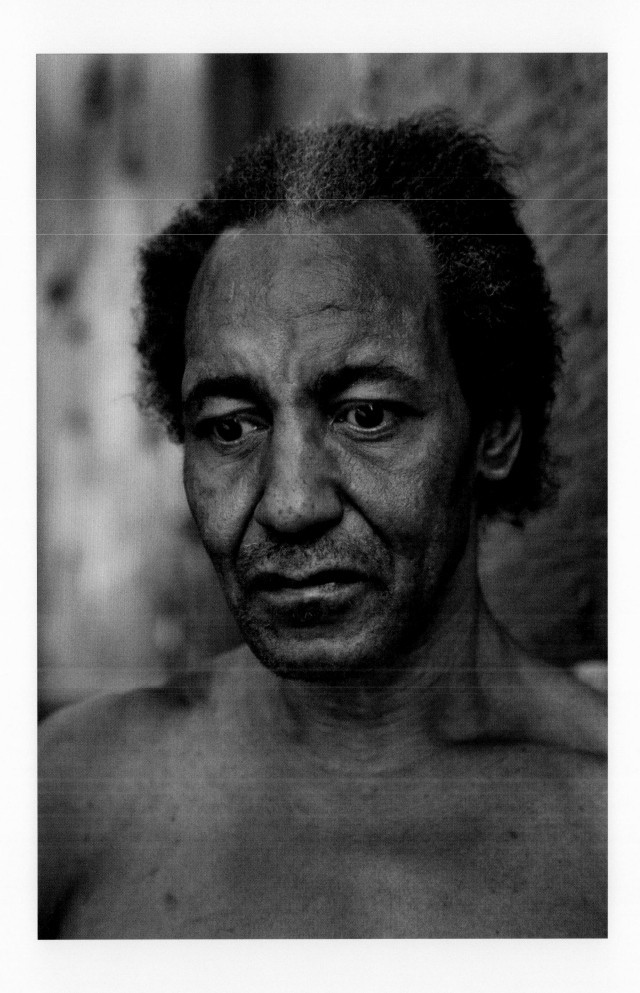

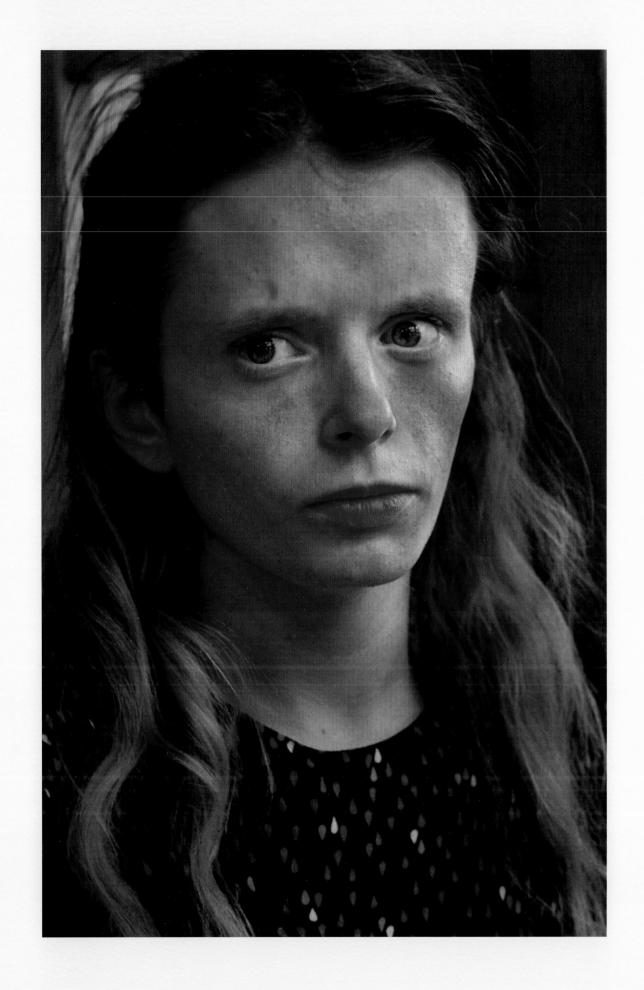

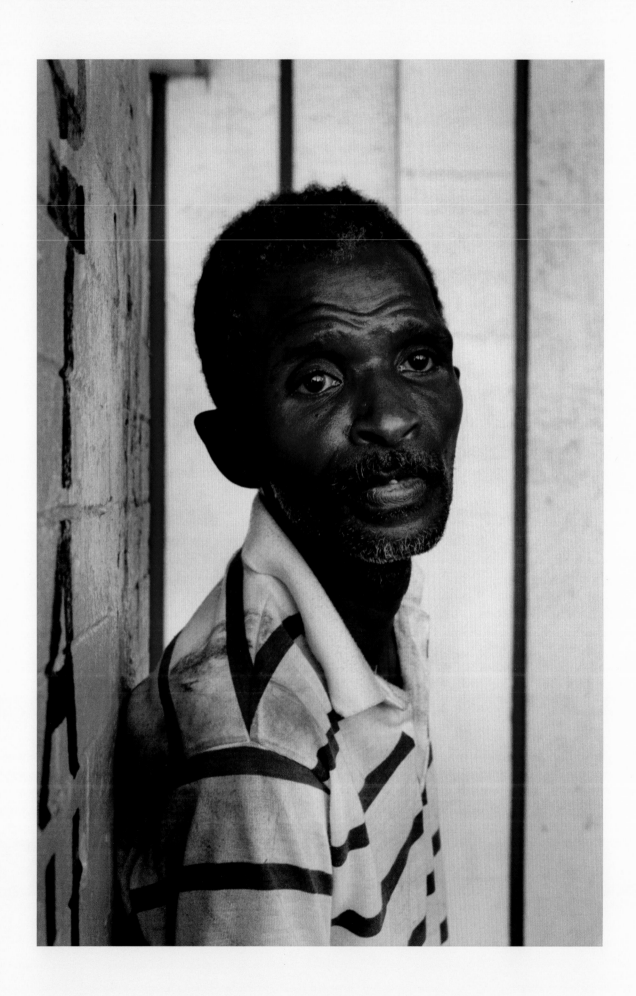

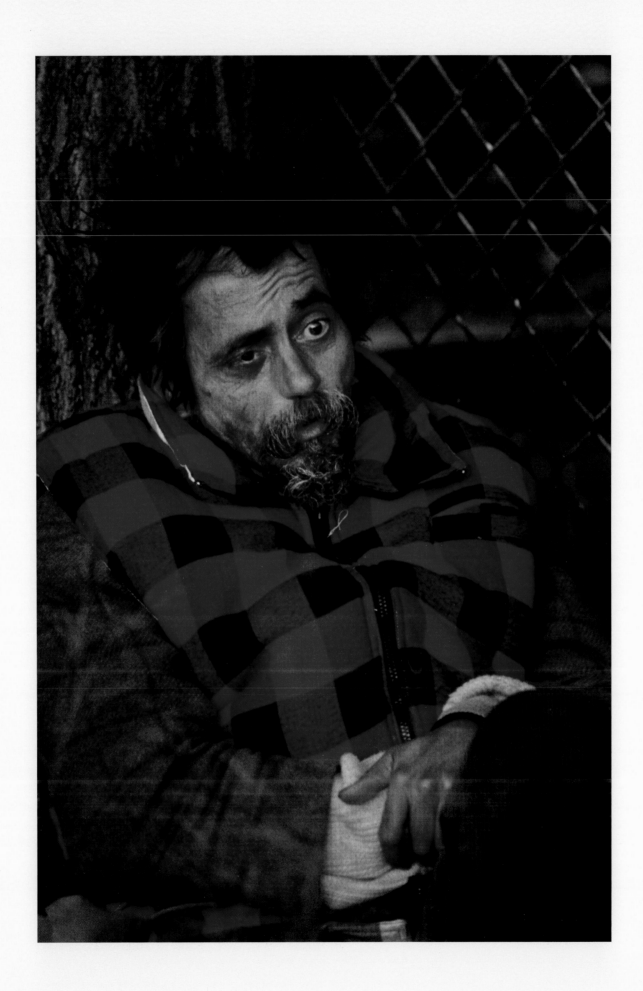

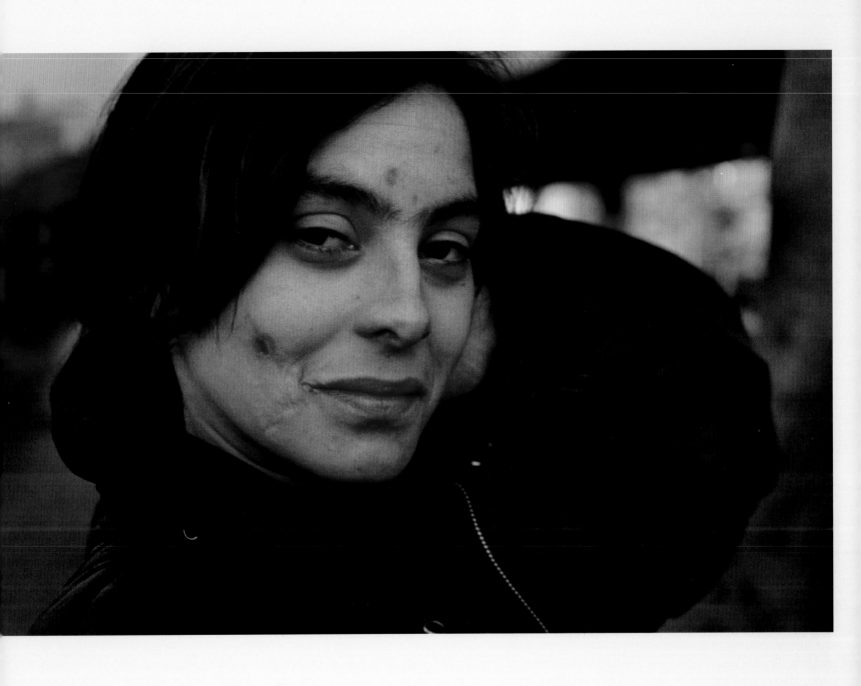

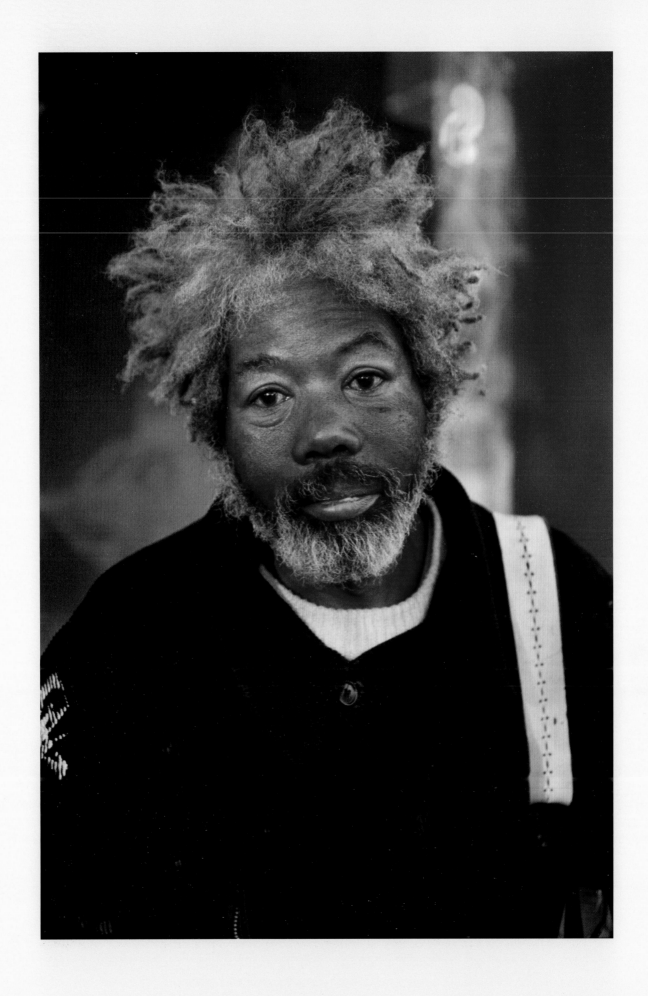

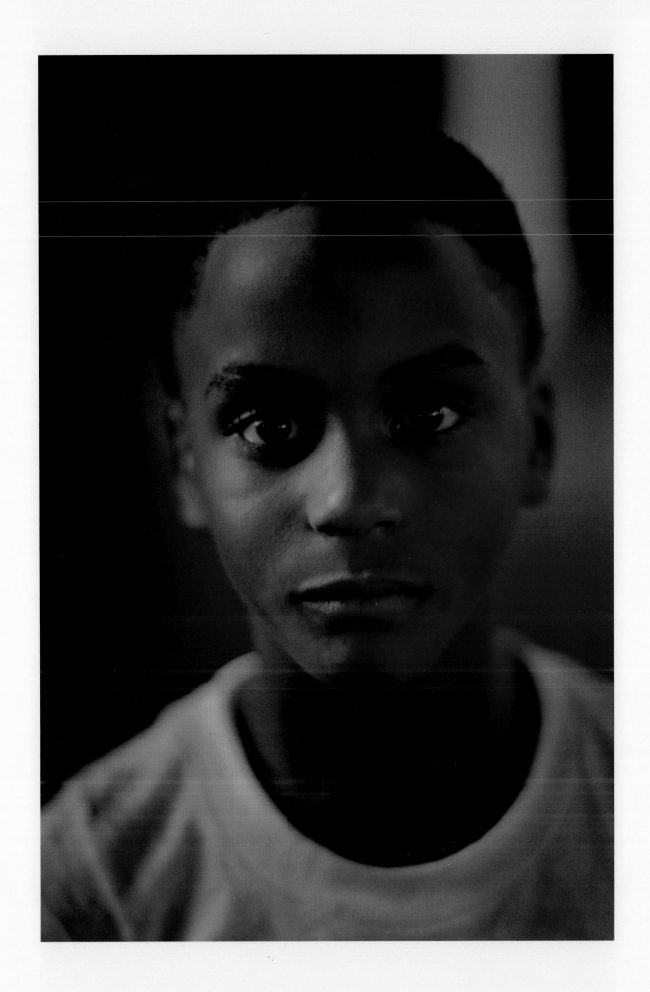

AFTERWORD

I have always, as far back as I can recall, delighted in the discovery of the works of certain photographers as highly individual and expressive revelations of self, and as unique perceptions of the visual and social world. While photography was downgraded by some painters and critics as mechanical (and all the more as the avant-garde painter turned away from the traditional requirements and norms of representation in painting for a pronounced freedom of imagination, inventiveness, and methods that brought to view the artist's process of work and the rigorous ordering of forms as well as play of fancy), photographers have nonetheless chosen viewpoints, moments in time, and qualities of the print new in aesthetic force and highly suggestive to painters who were committed to painting as an expressive art of the eye and the hand. Certain photographers—Robert Frank, as well as Robert Bergman, come to mind—discover, like the poets, otherwise ignored qualities of the person and environment, hidden moments of feeling, and present them to our entranced scrutiny—for our meditation.

The works of Robert Bergman have occasioned for me a new and moving experience of photography as an art. I am enchanted by their strength and delicacy. Here is a photographer particularly engaged in the exploration of the individual face as bearing the mark of a specific personal destiny. Robert Bergman's color portraits of people encountered by chance on the streets of American cities address the viewer with captivating simplicity and directness, in an idiom that is unencumbered by the norms or conventions of a period style. They are faces of people who move him deeply. With marvelous sensitivity and acumen, he scrutinizes each of them for individuality and for manifestations of otherwise unsoundable pervasive states and particular moments of feeling. The luminous insight, the palpable empathy and sympathy of his portraits, impel us to experience affinity, psychological nearness with the subject. A salient aspect of his building the image is the setting of the figure in an intimate environment that is rigorously ordered with respect to both the person and his or her background. This brings into play "constructed" forms that strengthen the figure and animate further the rectangle of the field and the contained contrasts and rhythms of the person and the surroundings. The resulting energy and beauty of forms imbue these portraits with unnameable yet compelling spiritual qualities.

The binding force in Bergman's work is the astonishingly immediate sense it gives us of the internality of the subject—the emotional and spiritual attitudes resident in the expression on the face, the extremes and nuances of inner life. A factor contributing to these effects is the combination of two modes of portrayal: the expressive features of the represented face are reinforced or even clarified by the expressive import of emotionally charged formal structures of the field. Bergman uses "invented" (discovered) forms and unique qualities of the print that are all purposive for the unity, singularity, intrinsic interest and drama of the individual. In fact, he has introduced the processes of unification, as in a painting, with the search for harmony, movement, variety, and distinction within it, beyond what I have ever seen in a photograph. His finest works bring to mind some of the greatest painted portraits.

The authenticity of Bergman's art appears in the "hypnotic" impact of faces that have attracted him as bearers of an unfathomable human presence, a self and a human condition. Here are masterful revelations of states of existence in the inner and outer person—truly profound works of art.

Meyer Schapiro

Grateful acknowledgment is made to BOA Editions, Ltd., for permission to reprint an excerpt from "The Fellowship with
Essence: An Afterword" from *Isabella Gardner: The Collected Poems* by Isabella Gardner. Copyright © 1990 by The Estate of
Isabella Gardner. Reprinted by permission of BOA Editions, Ltd., 260 East Ave., Rochester, N.Y. 14604.

PRODUCTION STAFF

Robert Hennessey / *Technical Supervision*

Erroll McDonald / *Editor*

Robert Bergman / *Color Separations*

LM, Michaelle Sparrow, and Mike Burk / *Printing Assistance*

Andy Hughes / *Production Management*

Susan Chun / *Production Consultation*

Don Hutcheson / *Color Management*

Martin Senn / *Finishing*

Barbara de Wilde / *Design*

Wilhelm Imaging Research, Inc. / *Image Technology and Preservation*

Coral Graphic Services, Inc. / *Offset Lithography*

Thanks also to Richard Benson, Roy Bohnen, Gary Fretheim, Franz Herbert, Joseph Holmes,
Brian Lawler, James Morgan, and Pam Smith.

The publisher gratefully acknowledges the technical assistance and support of the American Center for Photography.

Library of Congress Cataloging-in-Publication Data

Bergman, Robert.

A kind of rapture / photographs by Robert Bergman; introduction by Toni Morrison, afterword by Meyer Schapiro.

p. cm.

Exhibition catalog.

ISBN 0-679-44257-X

1. Portrait photography—United States—Exhibitions. 2. Bergman, Robert—Exhibitions. I. Title.

TR680.B452 1998 779'.2'092—DC21 98-16454 CIP

Random House Web Address: www.randomhouse.com

Printed in the United States of America

First Edition

2 4 6 8 9 7 5 3 1